JASONMLIPS @ GMAIL.COM
⊙ @ JASON_LIPS

ISBN- 978-1-0879-5799-9

SCRATCHING PAD

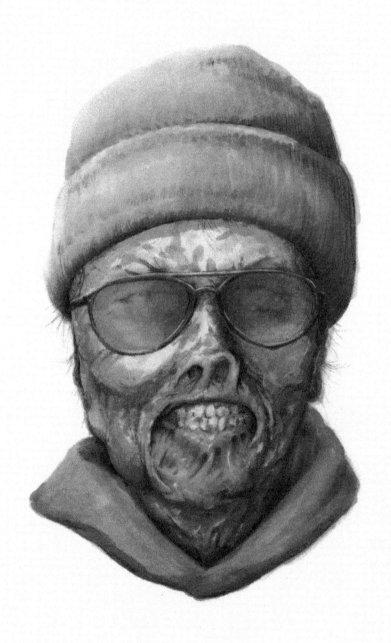

FOR HALEY & JUDAH
♡

Denim Rider

AND OTHER STORIES

WHY IS IT SO EASY TO DISTRACT MYSELF FROM DOING THE THINGS I REALLY WANT TO DO?

I'LL JUST DO A FEW DISHES, AND THEN I'LL WORK ON SOME COMICS.

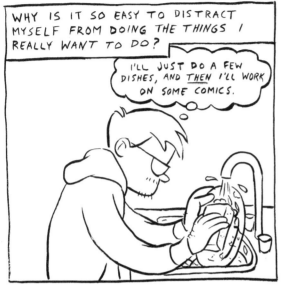

IS IT BECAUSE I'M AFRAID I ACTUALLY DON'T KNOW HOW TO DO THOSE THINGS AND I MIGHT FAIL? OR MAYBE I'M JUST FOOLING MYSELF AND I'D RATHER BE DOING HOUSEWORK IN THE END...

WELL, IF I'M GOING TO BE ABLE TO FOCUS ON A COMIC I'M GOING TO NEED SOME COFFEE

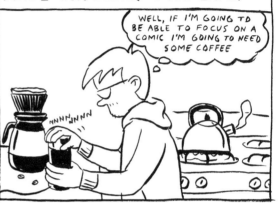

SOMETIMES I FEEL LIKE IT'S NOT EVEN WORTH GETTING STARTED BECAUSE I'LL PROBABLY GET DISTRACTED, LOSE FOCUS AND NOT BE ABLE TO GET BACK TO THAT IMMERSIVE FLOW WHERE THE REAL MAGIC HAPPENS.

I WONDER WHAT TIME EVERYONE IS COMING HOME?

SLURP

NO MATTER HOW MANY TIMES I FORGET IT, THE SOLUTION IS ALWAYS THE SAME.

OKAY I GUESS I'LL JUST GET STARTED ON SOMETHING...

...MAYBE I SHOULD CLEAN MY DESK FIRST? NO! JUST START DRAWING YOU IDIOT!

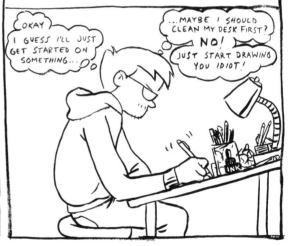

CONTENTS

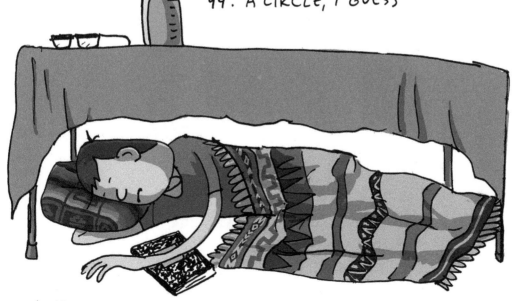

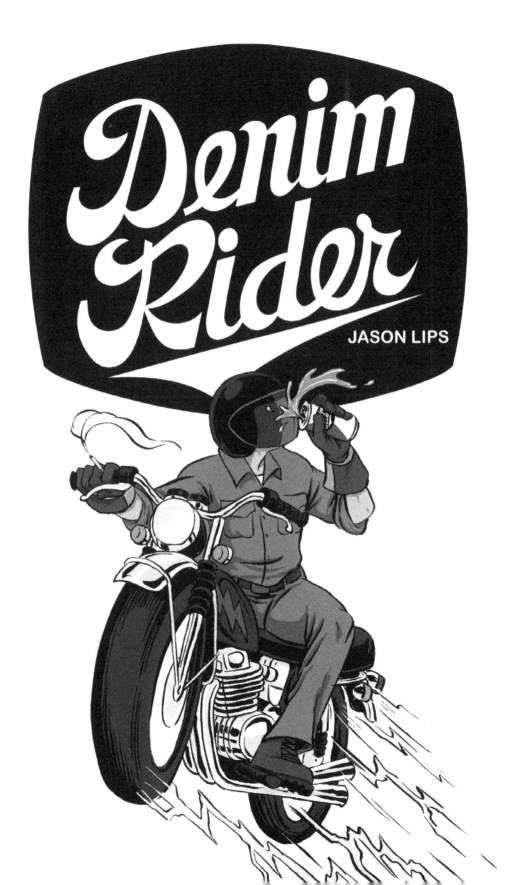

I TEACH ART AT AN EXPENSIVE PRIVATE HIGH SCHOOL IN KANSAS CITY.

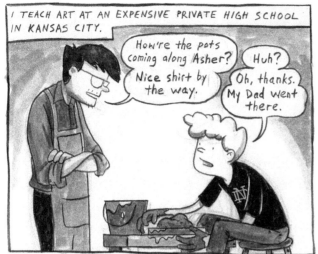

How're the pots coming along Asher?

Nice shirt by the way.

Huh?

Oh, thanks. My Dad went there.

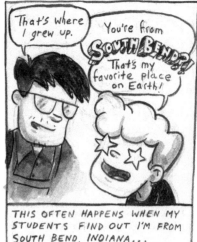

That's where I grew up.

You're from SOUTH BEND?! That's my favorite place on Earth!

THIS OFTEN HAPPENS WHEN MY STUDENTS FIND OUT I'M FROM SOUTH BEND, INDIANA...

ALWAYS WITH THE SAME EXCITED LOOK of DISBELIEF IN THEIR EYES AND SOUND of REVERENCE IN THEIR VOICE LIKE I JUST TOLD THEM I'M FROM the HOLY LAND or PARIS or SOMETHING.

Wow. Did you love it?

Um...

AS I BEGIN TO EXPLAIN MY EXPERIENCE of SOUTH BEND, INEVITABLY THEIR LOOK CHANGES TO SOMETHING LIKE "HE DOESN'T KNOW WHAT THE FUCK HE'S TALKING ABOUT."

Yeah, I guess my experience growing up there was a bit different.

I think I only went to Notre Dame once or twice my entire childhood.

And I definitely didn't know anyone who went to college there.

But its so nice there. We go a few times a year.

Is he really even from South Bend?!

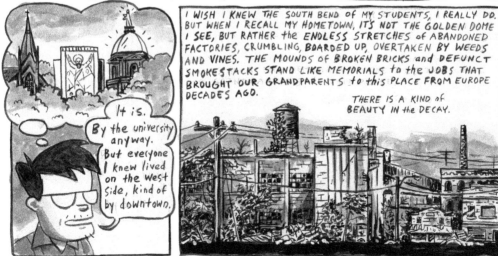

It is. By the university anyway. But everyone I knew lived on the west side, kind of by downtown.

I WISH I KNEW THE SOUTH BEND OF MY STUDENTS, I REALLY DO. BUT WHEN I RECALL MY HOMETOWN, IT'S NOT THE GOLDEN DOME I SEE, BUT RATHER the ENDLESS STRETCHES of ABANDONED FACTORIES, CRUMBLING, BOARDED UP, OVERTAKEN BY WEEDS AND VINES. THE MOUNDS OF BROKEN BRICKS and DEFUNCT SMOKESTACKS STAND LIKE MEMORIALS to the JOBS THAT BROUGHT OUR GRANDPARENTS to this PLACE FROM EUROPE DECADES AGO.

THERE IS A KIND of BEAUTY IN the DECAY.

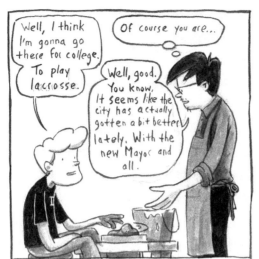

Well, I think I'm gonna go there for college. To play lacrosse.

Of course you are...

Well, good. You know, It seems like the city has actually gotten a bit better lately. With the new Mayor and all.

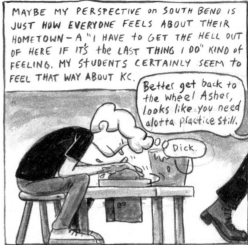

MAYBE MY PERSPECTIVE ON SOUTH BEND IS JUST HOW EVERYONE FEELS ABOUT THEIR HOMETOWN — A "I HAVE TO GET THE HELL OUT OF HERE IF IT'S the LAST THING I DO" KIND OF FEELING. MY STUDENTS CERTAINLY SEEM TO FEEL THAT WAY ABOUT KC.

Better get back to the wheel Asher, looks like you need alotta practice still.

Dick.

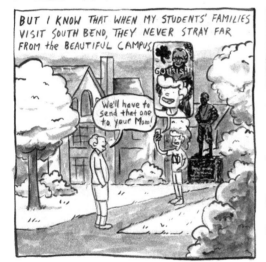

BUT I KNOW THAT WHEN MY STUDENTS' FAMILIES VISIT SOUTH BEND, THEY NEVER STRAY FAR FROM the BEAUTIFUL CAMPUS.

GO IRISH!

We'll have to send that one to your Mom!

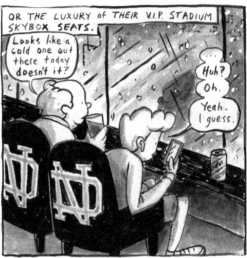

OR THE LUXURY OF THEIR V.I.P. STADIUM SKYBOX SEATS.

Looks like a cold one out there today doesn't it?

...Huh? Oh. Yeah. I guess.

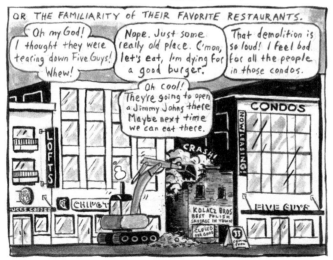

OR THE FAMILIARITY of THEIR FAVORITE RESTAURANTS.

Oh my God! I thought they were tearing down Five Guys! Whew!

Nope. Just some really old place. C'mon, let's eat, I'm dying for a good burger.

That demolition is so loud! I feel bad for all the people in those condos.

Oh cool! They're going to open a Jimmy Johns there. Maybe next time we can eat there.

CRASH!

LOFTS

CONDOS

NOW LEASING!

LUCES COFFEE

CHIPOTLE

KOLACZ BROS BEST POLISH SAUSAGE IN TOWN CLOSED FOR GOOD

FIVE GUYS

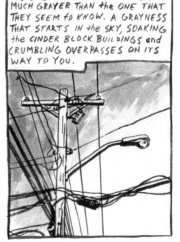

MY SOUTH BEND HAS ALWAYS BEEN MUCH GRAYER THAN the ONE THAT THEY SEEM to KNOW. A GRAYNESS THAT STARTS IN the SKY, SOAKING the CINDER BLOCK BUILDINGS and CRUMBLING OVERPASSES ON ITS WAY TO YOU.

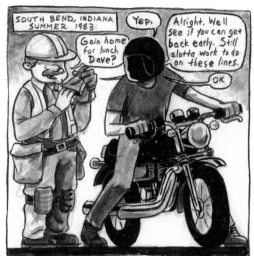

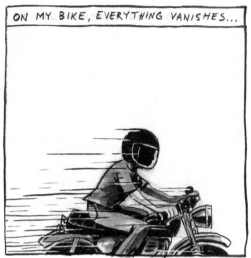

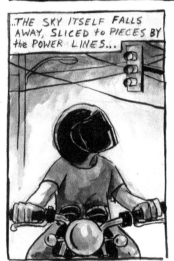

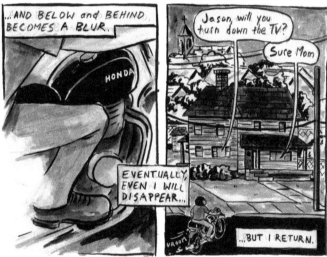

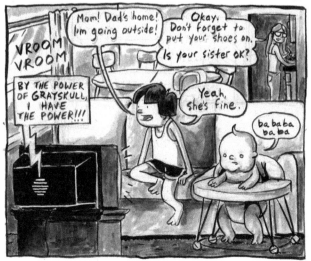

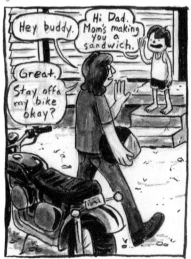

OUR BACKYARD IS MOSTLY JUST GRAVEL, CIGARETTE BUTTS and BITS OF BROKEN GLASS THAT GET STUCK IN YOUR FOOT and MAKE YOU BLEED if YOU DON'T WEAR YOUR SHOES LIKE YOU'RE SUPPOSED TO.

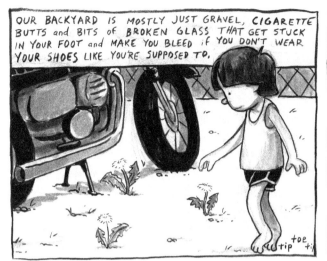

THERE ARE PRETTY DANDELIONS HERE and THERE THOUGH.

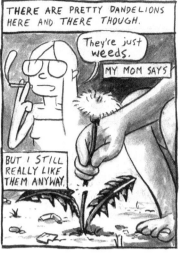

They're just weeds. MY MOM SAYS

BUT I STILL REALLY LIKE THEM ANYWAY.

OVER THERE BY THE FENCE IS the RHUBARB THAT I EAT WHEN I DON'T WANT to STOP PLAYING to GO IN and HAVE A SNACK.

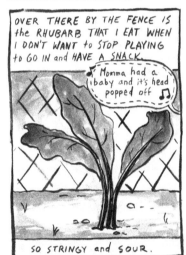

Momma had a baby and it's head popped off ♫

SO STRINGY and SOUR.

BACK OVER THERE BY the ALLEY IS WHERE WE KEEP OUR DOG BARON.

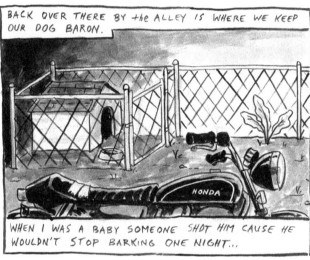

WHEN I WAS A BABY SOMEONE SHOT HIM CAUSE HE WOULDN'T STOP BARKING ONE NIGHT...

...HE WAS OK THOUGH.

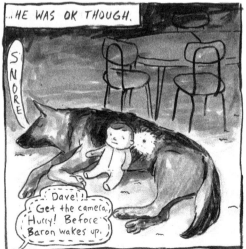

SNORE

Dave! Get the camera. Hurry! Before Baron wakes up.

ONE of the STORIES THAT OFTEN GETS TOLD ABOUT MY DAD IS the TIME HE COULDN'T SLEEP BECAUSE BARON WAS BARKING LIKE CRAZY SO HE WENT OUT THERE AND DUCT TAPED HIS MOUTH SHUT.

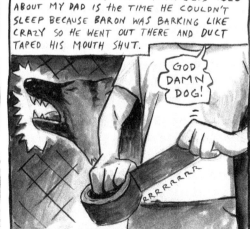

GOD DAMN DOG!

RRRRRRR

WHEN I TELL PEOPLE THIS STORY, THEY USUALLY RESPOND WITH SOMETHING LIKE, "THAT'S ANIMAL CRUELTY!!"

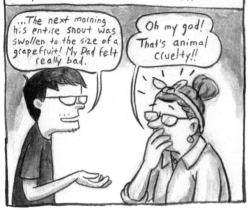

...The next morning his entire snout was swollen to the size of a grapefruit! My Dad felt really bad.

Oh my god! That's animal cruelty!!

OBVIOUSLY I UNDERSTAND WHY PEOPLE WOULD RESPOND THAT WAY. BUT IT'S STORIES LIKE THIS THAT HUMANIZE MY DAD, KEEPING ME FROM IDOLIZING HIM INTO SOME KIND OF HERO.

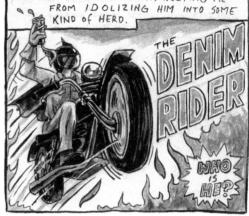

THE DENIM RIDER

WHO IS HE?

I'VE ALWAYS CLUNG TO ANY STORIES I HEAR ABOUT MY DAD, GOOD OR BAD.

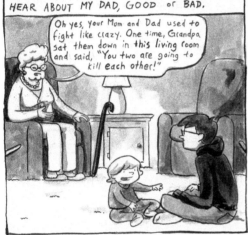

Oh yes, your Mom and Dad used to fight like crazy. One time, Grandpa sat them down in this living room and said, "You two are going to kill each other!"

ANOTHER ONE I'VE HEARD WAS WHEN MY DAD WAS IN HIGH SCHOOL HE WAS ON ACID IN HIS BEDROOM WHEN SOME KID KNOCKED ON THE FRONT DOOR WANTING TO FIGHT HIM. MY DAD PROCEEDED TO PUMMEL THE POOR KID IN THE FRONT YARD WHILE MY GRANDPA SUPERVISED.

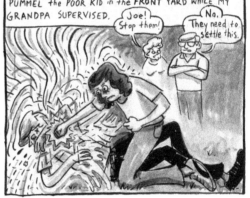

Joe! Stop them!

No. They need to settle this.

AS CRAZY AS THAT STORY IS, IT ACTUALLY MADE ME FEEL MORE CONNECTED WITH MY DAD, LIKE IF WE HAD GONE TO HIGH SCHOOL TOGETHER WE'D TOTALLY HAVE BEEN FRIENDS.

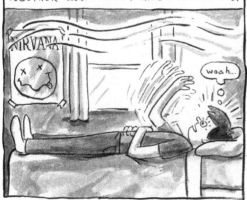

NIRVANA

woah...

IT'S WEIRD HOW A PERSON SO IMPORTANT TO YOUR LIFE CAN BECOME SUCH AN ABSTRACTION. MY DAD WAS NO SUPERHERO, BUT I DON'T THINK HE WAS A VILLAIN EITHER. IT TAKES SOME EFFORT, BUT I TRY TO REMEMBER THAT HE WAS JUST A GUY. A GUY WHO WAS UNFORTUNATELY FROZEN IN ALL OF OUR MEMORIES AT JUST THIRTY YEARS OLD

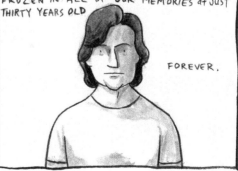

FOREVER.

BUT FOR NOW MY DAD IS HERE, and ONE of MY FAVORITE THINGS to DO is PLAY ON HIS MOTORCYCLE.

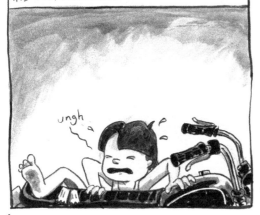

SQUEEZING THE BLACK RUBBER HANDLES, FLIPPING ALL THE SWITCHES BACK and FORTH, THE CLICKS SOUND SO GOOD.

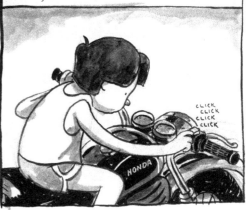

PICKING and PEELING AT the GUMMY EDGE OF THE DUCT-TAPE PATCHING A TEAR IN THE SEAT.

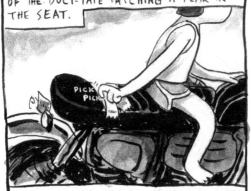

I KNOW ALL of THIS DRIVES MY DAD CRAZY BUT I JUST CAN'T HELP MYSELF.

IT WON'T BE LONG FROM NOW...

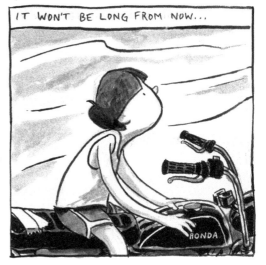

OR FAR FROM THIS VERY SPOT...

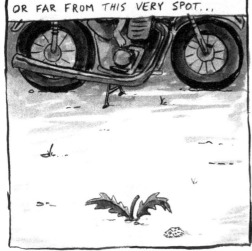

WHEN THE ELECTRICITY THAT BUZZES THROUGH THESE LINES...

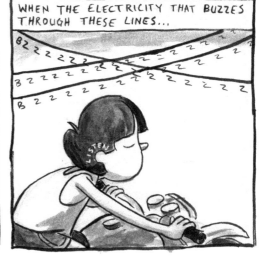

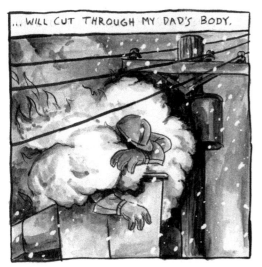

... WILL CUT THROUGH MY DAD'S BODY.

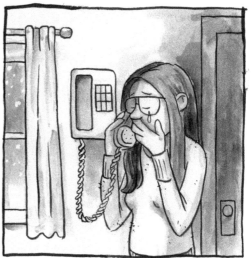

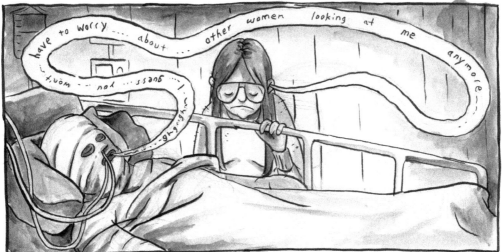

have to worry about ... other women looking at me anymore ... I ... guess ... not ... won't ... ghgsgh ...

HE WAS SOON MOVED TO A SPECIAL BURN CLINIC THREE HOURS AWAY. MY SISTER and I WENT to GO STAY at OUR AUNT and UNCLE'S HOUSE SO MOM COULD BE THERE WITH HIM.

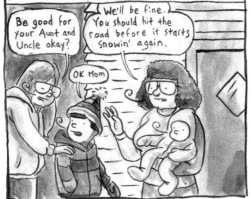

Be good for your Aunt and Uncle okay?

OK Mom

We'll be fine. You should hit the road before it starts snowin' again.

MY COUSINS WERE AROUND MY AGE, PLUS THEY HAD TONS of COOL STUFF WE DIDN'T HAVE: CABLE (MTV!), ATARI, A ROCK TUMBLER, SHRINKY-DINKS, and AN EASY BAKE OVEN, SO IT WAS ACTUALLY PRETTY FUN BEING THERE...

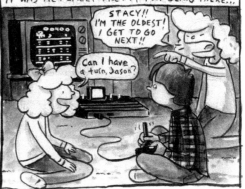

STACY!! I'M THE OLDEST! I GET TO GO NEXT!!

Can I have a turn, Jason?

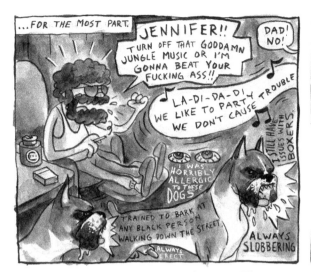

...FOR THE MOST PART.

JENNIFER!! TURN OFF THAT GODDAMN JUNGLE MUSIC OR I'M GONNA BEAT YOUR FUCKING ASS!!

DAD! NO!

LA-DI-DA-DI WE LIKE TO PARTY WE DON'T CAUSE TROUBLE

I WAS HORRIBLY ALLERGIC TO THESE DOGS

I STILL HAVE ISSUES WITH BOXERS.

TRAINED TO BARK AT ANY BLACK PERSON WALKING DOWN THE STREET.

ALWAYS ERECT

ALWAYS SLOBBERING

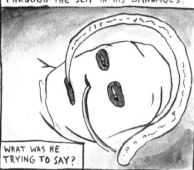

TIME PASSED NORMALLY. ONE TIME MY SISTER AND I WERE TAKEN to VISIT OUR DAD IN the HOSPITAL.

I REMEMBER THE RAW FLESH AROUND HIS BARELY OPEN EYES AS HE HISSED and GARGLED SOMETHING to ME THROUGH THE SLIT IN HIS BANDAGES.

WHAT WAS HE TRYING TO SAY?

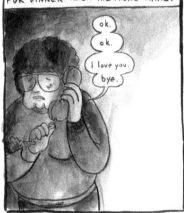

NOT LONG AFTER THAT WE WERE AT GRANDMA and GRANDPA'S HOUSE FOR DINNER WHEN the PHONE RANG.

ok.

ok.

I love you.

bye.

IT WASN'T UNTIL THAT PHONE CALL THAT I'D EVEN REMOTELY UNDERSTOOD WHAT WAS HAPPENING WITH MY DAD. MY GRANDMA'S EXPRESSION AND HUSHED VOICE CAUSED ME to SUDDENLY REALIZE THAT MY DAD HAD DIED. I RAN INTO MY GRANDPARENTS' BEDROOM.

Jason, can I come in?

⟨sob⟩ ⟨sniff⟩ NO! Leave me alone. ⟨sniff⟩

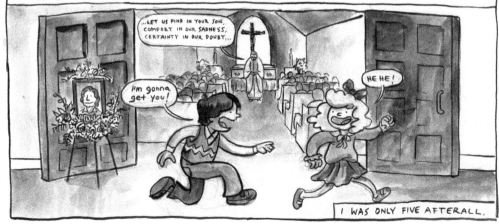

BUT, BY THE TIME of HIS FUNERAL, JUST a FEW DAYS BEFORE CHRISTMAS, I'D SAY I DIDN'T REALLY COMPREHEND the SIGNIFICANCE of WHAT HAD HAPPENED ONCE AGAIN.

...LET US FIND IN YOUR SON, COMFORT IN OUR SADNESS, CERTAINTY IN OUR DOUBT...

I'm gonna get you!

HE HE!

I WAS ONLY FIVE AFTERALL.

THE NIGHT AFTER THE FUNERAL WE HAD A SURPRISE VISITOR.

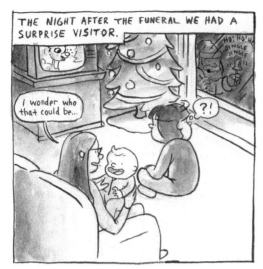

SANTA BROUGHT MY SISTER and I a SPECIAL ROUND OF EARLY PRESENTS. HE EVEN HUNG OUT WITH US IN OUR LIVING ROOM FOR A WHILE.

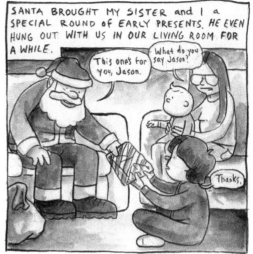

WHO WAS SANTA? MY GRANDPA? ONE OF MY DAD'S CO-WORKERS OR FRIENDS? WHOEVER IT WAS THAT MUST'VE BEEN SO HARD FOR THEM TO DO. TO THIS DAY MY MOM STILL INSISTS IT WAS the REAL SANTA.

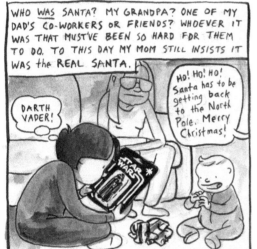

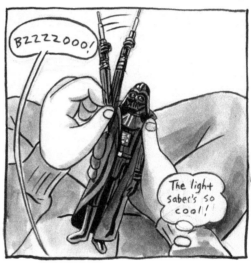

IF MY DAD HAD SURVIVED HIS INJURIES, WOULD HE HAVE LOOKED SOMETHING LIKE DARTH VADER WHEN LUKE REMOVES HIS MASK IN RETURN of the JEDI?

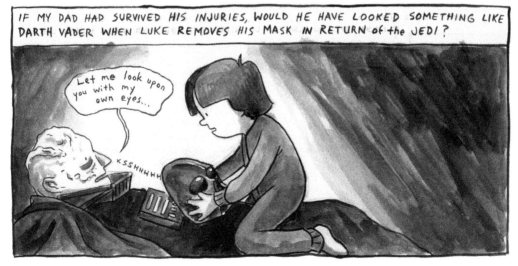

17

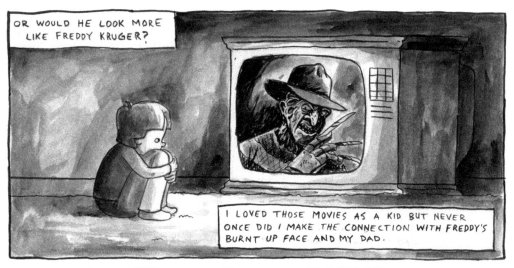

OR WOULD HE LOOK MORE LIKE FREDDY KRUGER?

I LOVED THOSE MOVIES AS A KID BUT NEVER ONCE DID I MAKE THE CONNECTION WITH FREDDY'S BURNT UP FACE AND MY DAD.

BUT WERE MY MOM AND THE OTHER ADULTS HORRIFIED WHEN I CHOSE TO BE FREDDY FOR HALLOWEEN JUST A FEW YEARS LATER?

MY COSTUME WAS OKAY, BUT MY MOM DREW THE LINE AT THE IDEA OF CUTTING UP MY NICE STRIPED SWEATER.

UGH! This stupid skin putty keeps falling off!

COOL NEW HAIRCUT

SKIN

FAKE BLOOD

THERE WAS THIS KID at SCHOOL, ANTHONY, WHO HAD BURN SCARS ALL OVER HIS FACE AND ARMS. HE WAS IN SPECIAL ED, SO I ONLY EVER SAW HIM IN THE HALLS DURING BATHROOM BREAKS and STUFF.

ANTHONY WAS INTO ART JUST LIKE ME SO SOMETIMES WE'D SHOW EACH OTHER OUR DRAWINGS.

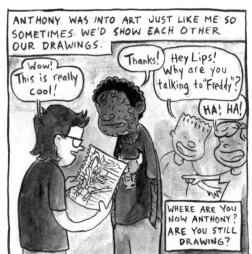

Wow! This is really cool!

Thanks! Hey Lips! Why are you talking to "Freddy"?

HA! HA!

WHERE ARE YOU NOW ANTHONY? ARE YOU STILL DRAWING?

I SO RARELY SEE PEOPLE WITH SEVERE BURN SCARS. MAYBE MOST JUST DON'T SURVIVE THOSE KINDS of INJURIES. OR MAYBE THEY JUST DON'T GO OUT MUCH BECAUSE of ALL the STARING. THERE IS THIS MAN I SEE OCCASIONALLY AT the NEIGHBORHOOD PARK and AT THE GROCERY STORE. I KNOW I STARE.

SECRETLY I HOPE.

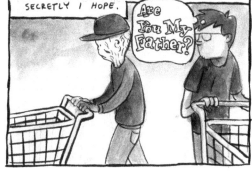

Are You My Father?

IT WAS STRANGE to TURN THIRTY, THE AGE MY DAD WAS WHEN HE DIED. THIS REALIZATION LED to ALL KINDS of IDEAS — GROWING MY HAIR LONG LIKE HIS, QUITTING MY JOB to BECOME an ELECTRICAL LINEMAN LIKE HIM. LUCKILY I DIDN'T FOLLOW THROUGH ON ANY of THEM.

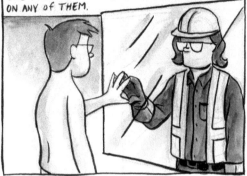

BUT MAYBE I COULD JUST GET the SAME MOTORCYCLE HE HAD, A 1979 HONDA CB550...

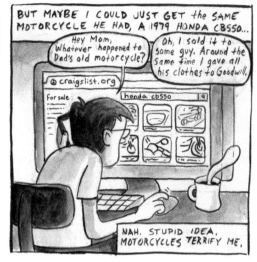

Hey Mom, Whatever happened to Dad's old motorcycle?

Oh, I sold it to some guy. Around the same time I gave all his clothes to Goodwill.

NAH. STUPID IDEA, MOTORCYCLES TERRIFY ME.

MY OBSESSION WITH MY DAD ONLY GREW AFTER I BECAME A FATHER MYSELF.

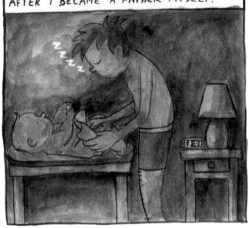

AROUND THIS TIME I HAD A MEMORY OF BEING AT MY GRANDMA'S HOUSE ONE CHRISTMAS. THEIR OLD HOME MOVIES FROM THE '50s WERE PLAYING ON THE TV.

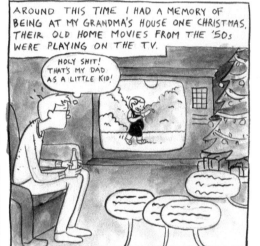

HOLY SHIT! THAT'S MY DAD AS A LITTLE KID!

I ASKED MY GRANDMA IF I COULD HAVE A COPY OF THE VIDEO BUT SHE HAD NO IDEA WHAT I WAS TALKING ABOUT.

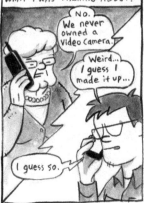

No. We never owned a video camera.

Weird... I guess I made it up...

I guess so.

I COULDN'T LET the IDEA GO THAT SOMEWHERE OUT THERE MUST BE a VIDEO of MY DAD.

IF I COULD JUST SEE HIM MOVE, IF I COULD JUST HEAR HIS VOICE, I'M SURE IT WOULD DO SOMETHING FOR ME.

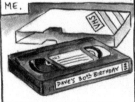

DAVE'S 30th BIRTHDAY

AS FAR AS I CAN TELL, NO SUCH TAPE EXISTS.

BUT the SUBCONSCIOUS HAS ITS WAYS OF MEETING THE CONSCIOUS MIND'S NEEDS. SOON AFTER I'D GIVEN UP ON FINDING VIDEO OF MY DAD I HAD A DREAM THAT I WAS AT A PARTY MY PARENTS WERE HAVING at OUR OLD HOUSE.

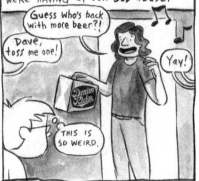

Guess who's back with more beer?!

Dave, toss me one!

Yay!

Denim Rider

THIS IS SO WEIRD.

MY SUBCONSCIOUS ALSO LED ME to READ "STIFF" BY MARY ROACH.

SO WAIT, AS LONG AS the BURIAL VAULT DOESN'T CRACK THE BODY IS PRESERVED LITERALLY FOREVER?!

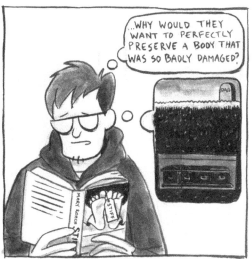

..WHY WOULD THEY WANT TO PERFECTLY PRESERVE A BODY THAT WAS SO BADLY DAMAGED?

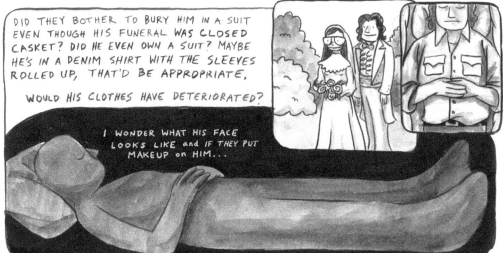

DID THEY BOTHER TO BURY HIM IN A SUIT EVEN THOUGH HIS FUNERAL WAS CLOSED CASKET? DID HE EVEN OWN A SUIT? MAYBE HE'S IN A DENIM SHIRT WITH THE SLEEVES ROLLED UP, THAT'D BE APPROPRIATE.

WOULD HIS CLOTHES HAVE DETERIORATED?

I WONDER WHAT HIS FACE LOOKS LIKE and IF THEY PUT MAKEUP on HIM...

Okay, she's asleep.

20

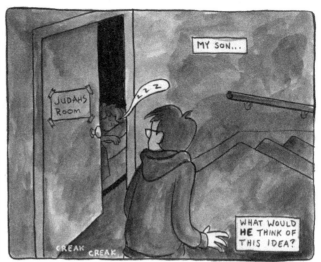

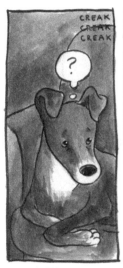

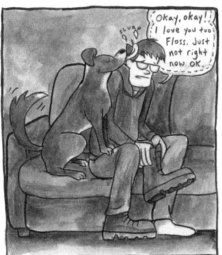

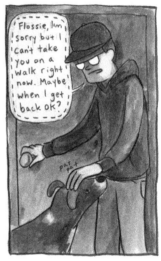

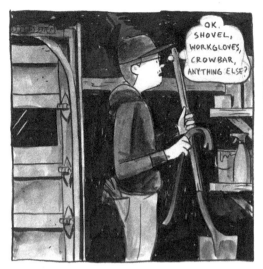

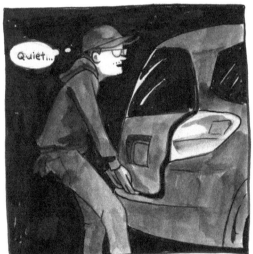

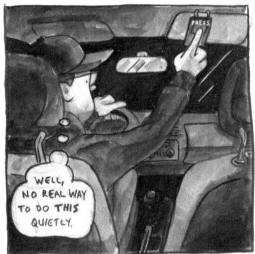

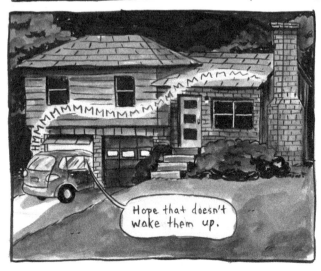

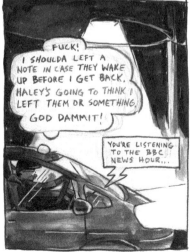

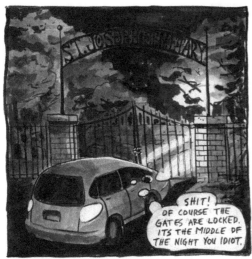

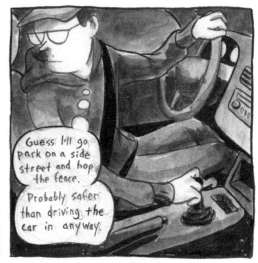

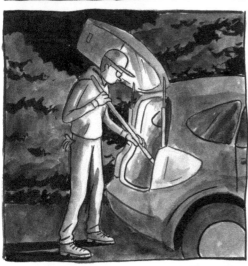

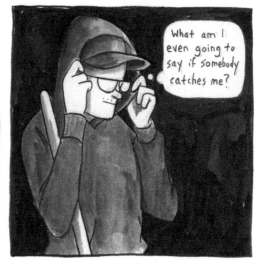

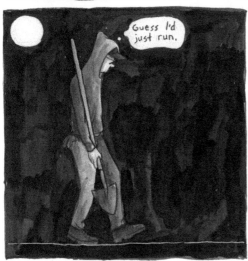

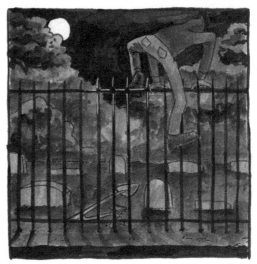

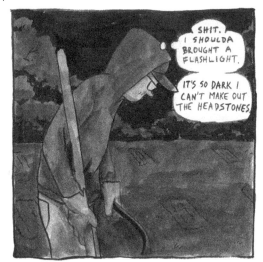

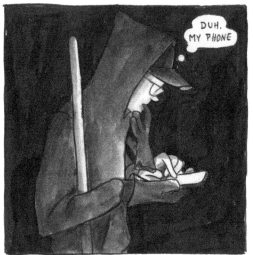

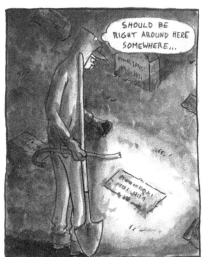

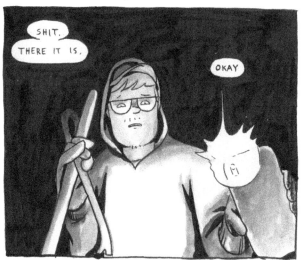

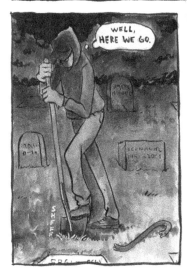

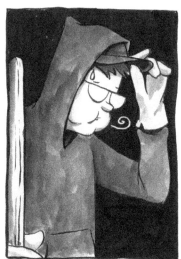

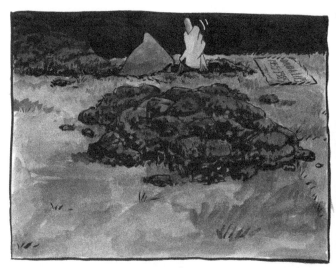
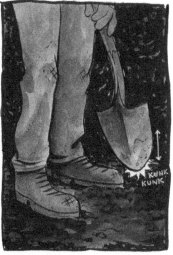
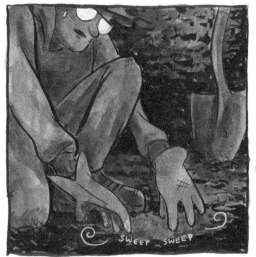

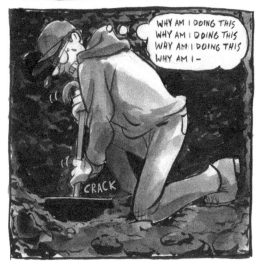
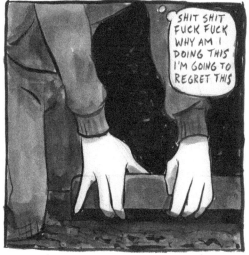

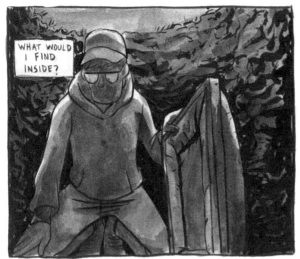

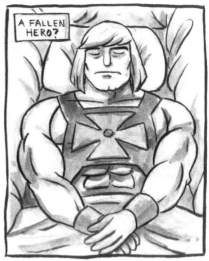

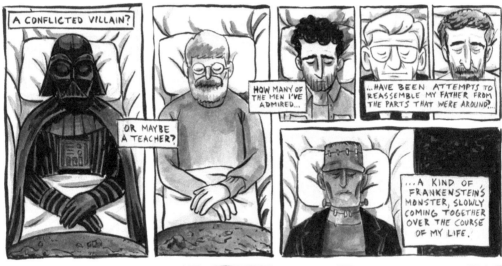

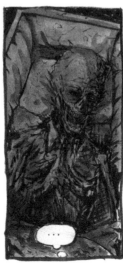

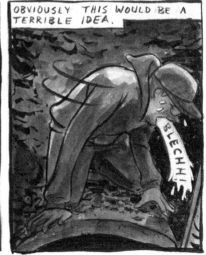

I SOMETIMES WONDER IF MY DAD HADN'T DIED, IF HE AND MY MOM WOULD'VE STAYED MARRIED. MAYBE HIS DEATH WAS THE ONLY THING THAT SAVED ME FROM HAVING DIVORCED PARENTS LIKE MOST OF MY FRIENDS.

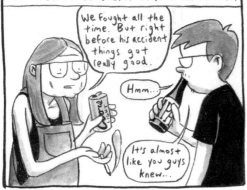

We fought all the time. But right before his accident things got really good.

Hmm...

It's almost like you guys knew...

WOULD HE AND I BE CLOSE? WOULD I EVER HAVE BECOME AN ARTIST OR WOULD I HAVE GOTTEN INTO THE THINGS HE LIKED?

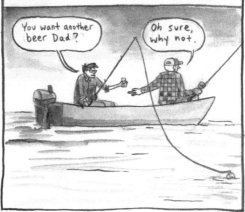

You want another beer Dad?

Oh sure, why not.

DOUBT I WOULD'VE EVER LEFT INDIANA. PROBABLY WOULD BE A CARPENTER OR HVAC GUY OR SOMETHING.

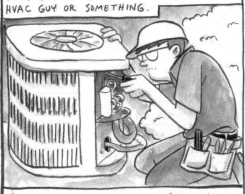

I'M SURE I'D MAKE A HELL OF A LOT MORE MONEY THAN I DO TEACHING ART.

STILL BE HANGING OUT WITH MY HIGH SCHOOL FRIENDS. WHO KNOWS, MAYBE THAT WOULD'VE LEAD SOMEWHERE COOL?

So, I wanted to ask you something, with all the homebrewing we've been doing, would you want to start a brewery together?

I GUESS I'D HAVE A TOTALLY DIFFERENT FAMILY AS WELL. WHOEVER I WOULD'VE MARRIED, I'M SURE WE'D PROBABLY ALREADY BE DIVORCED.

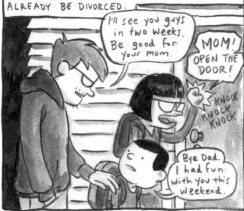

I'll see you guys in two weeks. Be good for your mom.

MOM! OPEN THE DOOR!

KNOCK KNOCK KNOCK

Bye Dad. I had fun with you this weekend.

I THINK ABOUT ALL THE SILENT, BROODING FATHERS I KNEW AS A KID, SITTING IN THEIR CHAIRS, DRINKING BEER, WATCHING SPORTS, LETTING OUT THE OCCASIONAL YELL TO REMIND THEIR WIFE AND KIDS WHO WAS IN CHARGE. WAS MY DAD JUST LIKE THEM? IS THAT WHAT I WOULD HAVE BECOME?

CLICK CLICK CLICK

WHENEVER WE GO BACK TO INDIANA TO VISIT I LIKE TO DRIVE PAST OUR OLD HOUSE AT LEAST ONCE.

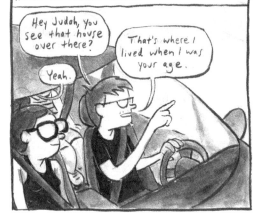

Hey Judah, you see that house over there?

That's where I lived when I was your age.

Yeah.

LIKE SO MANY PLACES, THE OLD NEIGHBOR-HOOD HAS CHANGED A LOT OVER THE YEARS and MANY of MY FAMILY MEMBERS DON'T HAVE MUCH GOOD to SAY ABOUT IT.

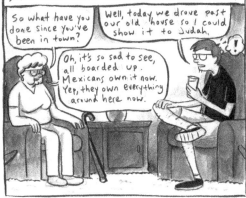

So what have you done since you've been in town?

Well, today we drove past our old house so I could show it to Judah.

Oh, it's so sad to see, all boarded up. Mexicans own it now. Yep, they own everything around here now.

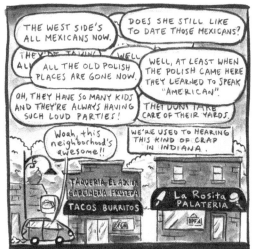

THE WEST SIDE'S ALL MEXICANS NOW.

DOES SHE STILL LIKE TO DATE THOSE MEXICANS?

THEY'RE TAKING ALL THE OLD POLISH PLACES ARE GONE NOW.

WELL, AT LEAST WHEN THE POLISH CAME HERE THEY LEARNED TO SPEAK "AMERICAN".

OH, THEY HAVE SO MANY KIDS AND THEY'RE ALWAYS HAVING SUCH LOUD PARTIES!

THEY DON'T TAKE CARE OF THEIR YARDS.

Woah, this neighborhood's awesome!!

WE'RE USED TO HEARING THIS KIND OF CRAP IN INDIANA.

TAQUERIA EL ANA CARCINERIA FRUTERA
TACOS BURRITOS

La Rosita PALATERIA

BUT THE POLISH PLACES WERE PRETTY MUCH ALL GONE BY THE TIME I WAS BORN. AND TO MY EYES THE OLD NEIGHBORHOOD IS ACTUALLY PRETTY COOL NOW.

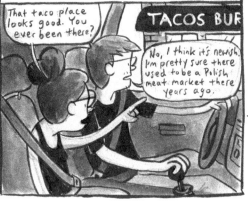

That taco place looks good. You ever been there?

No, I think it's newish. I'm pretty sure there used to be a Polish meat market there years ago.

TACOS BUR

JUST ACROSS THE STREET FROM OUR OLD HOUSE IS A PALATERIA WE LIKE TO VISIT. USUALLY THERE'S A LINE OUT THE DOOR.

What flavor are you gonna get?

I kind of wanna "walking taco" actually.

AND WHILE OUR OLD HOUSE DID LOOK ROUGH FOR A NUMBER OF YEARS, IT'S PRETTY NICE NOW, CERTAINLY BETTER THAN WHEN WE OWNED IT.

I OFTEN FANTASIZE ABOUT KNOCKING ON the DOOR AND ASKING the CURRENT OWNER IF I CAN HAVE A TOUR OF THE HOUSE.

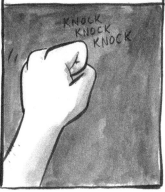

KNOCK KNOCK KNOCK

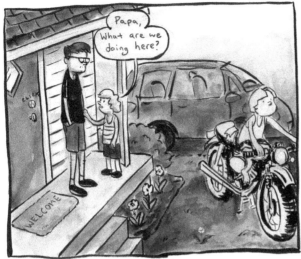

Papa, what are we doing here?

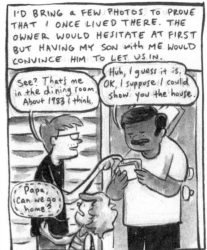

I'D BRING A FEW PHOTOS TO PROVE THAT I ONCE LIVED THERE. THE OWNER WOULD HESITATE AT FIRST BUT HAVING MY SON WITH ME WOULD CONVINCE HIM TO LET US IN.

See? That's me in the dining room. About 1983 I think.

Huh, I guess it is. OK, I suppose I could show you the house.

Papa, can we go home?

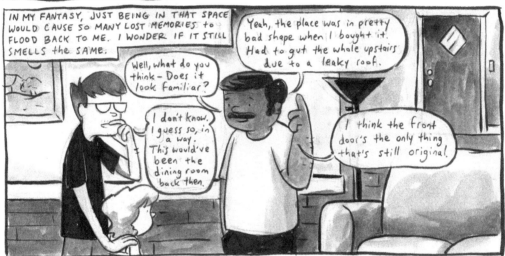

IN MY FANTASY, JUST BEING IN THAT SPACE WOULD CAUSE SO MANY LOST MEMORIES TO FLOOD BACK TO ME. I WONDER IF IT STILL SMELLS THE SAME.

Well, what do you think — Does it look familiar?

I don't know. I guess so, in a way. This would've been the dining room back then.

Yeah, the place was in pretty bad shape when I bought it. Had to gut the whole upstairs due to a leaky roof.

I think the front door's the only thing that's still original.

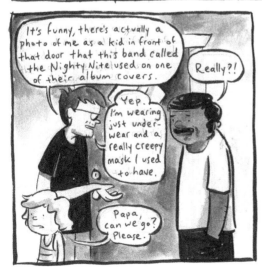

It's funny, there's actually a photo of me as a kid in front of that door that this band called the Nighty Nite used on one of their album covers.

Really?!

Yep. I'm wearing just underwear and a really creepy mask I used to have.

Papa, can we go? Please.

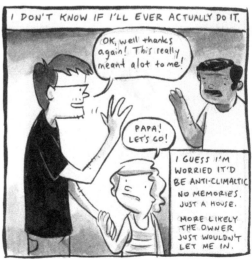

I DON'T KNOW IF I'LL EVER ACTUALLY DO IT.

OK, well thanks again! This really meant alot to me!

PAPA! LET'S GO!

I GUESS I'M WORRIED IT'D BE ANTI-CLIMALTIC. NO MEMORIES. JUST A HOUSE.

MORE LIKELY THE OWNER JUST WOULDN'T LET ME IN.

WE SOLD THAT HOUSE and MOVED OUT to THE COUNTRY
So I WOULD GO to a "BETTER" ELEMENTARY SCHOOL,
and FOR MORE SPACE and QUIET. IT WAS MY DAD'S DREAM.

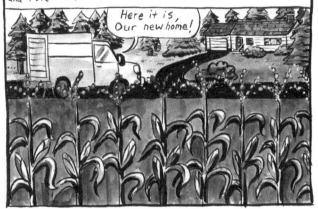

HE SAID THAT OUR FIRST NIGHT
IN THE NEW HOUSE WAS the
BEST SLEEP OF HIS LIFE.

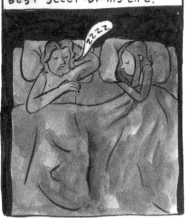

I ONLY HAVE TWO MEMORIES OF MY DAD AT
the NEW HOUSE, AN IMAGE OF HE AND MY
GRANDPA WORKING on the BASEMENT FLOOR...

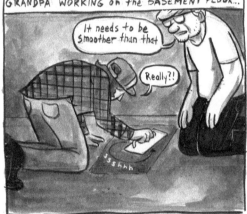

...AND WATCHING HIM BURN DOWN AN OLD
PIG PEN IN OUR BACKYARD.

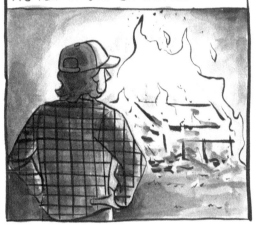

UNFORTUNATELY, HE WOULD NOT GET MANY MORE
NIGHTS OF GREAT SLEEP IN THIS HOUSE. HIS ACCIDENT
HAPPENED JUST TWO MONTHS AFTER WE MOVED IN.

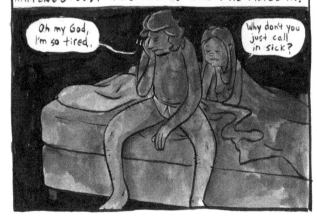

THEY HAD GONE to CHICAGO the
DAY BEFORE to SEE THE BEARS
PLAY. HE WAS EXHAUSTED AND
PROBABLY A BIT HUNGOVER TOO,

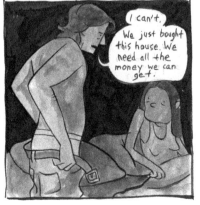

WELL OVER THIRTY YEARS after MY DAD'S DEATH, MY MOM STILL LIVES IN THAT HOUSE, NEITHER ABLE to KEEP UP WITH IT or LET IT GO, EVEN STILL KEEPING HER HAIR LONG JUST BECAUSE IT WAS HOW MY DAD LIKED IT.

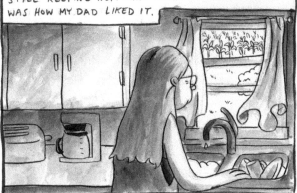

THE ELM TREES IN THE YARD ARE DEAD or DYING. THE PINES are BEING CHOKED by HONEYSUCKLE.

MY OLD BEDROOM NOW a STORAGE SPACE. BOOKS of FAMILY PHOTOS SPREAD OUT on THE FLOOR and FURNITURE IN SOME SORT of DECADES LONG ORGANIZATION EFFORT.

NOBODY IS ALLOWED UPSTAIRS WHERE my PARENTS' BEDROOM WAS and WHERE IT NOW SMELLS of DAMP WOOD.

I WALK the PROPERTY and RUMMAGE THROUGH the GARAGE, TRYING to SENSE the PRESENCE of MY DAD.

Jason, where are you?

In the garage! I'll be right there.

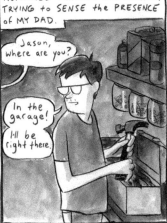

BUT IT TURNS OUT THE DEAD DON'T ACTUALLY HAUNT HOUSES as MUCH as THEY HAUNT US.

BRRINNG, BRRINNG

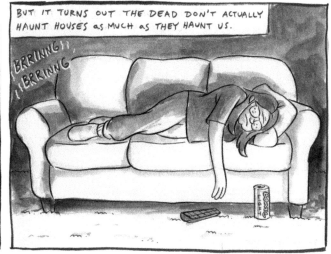

31

I WONDER WHAT MY MOM'S DEPRE-SSION FEELS LIKE, and WHEN IT BEGAN.

Hi Mom, How are you?

hi. oh... you know, tired.

SHE WOULD SAY IT STARTED WHEN MY DAD DIED. BUT I DON'T KNOW. WHEN I LOOK AT FAMILY PHOTOS from WHEN HE WAS STILL ALIVE I ALREADY SEE that SAME LOOK ON HER FACE that I KNOW TODAY.

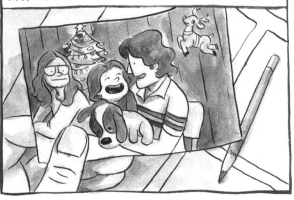

IT'S the SAME PENSIVE SMILE HER FATHER ALWAYS HAD. HE TOO DIED IN a TRAGIC, WORK-RELATED ACCIDENT, LESS THAN a YEAR AFTER MY DAD.

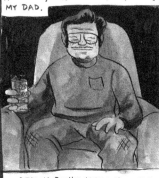

I REALLY DON'T KNOW HOW SHE MADE IT THROUGH THAT YEAR.

I'VE ALWAYS THOUGHT I WAS IMMUNE to DEPRESSION MYSELF, BUT IN THE LAST FEW YEARS a KIND OF HEAVY GRAY OOZE HAS BEEN COMING OVER ME MORE and MORE OFTEN.

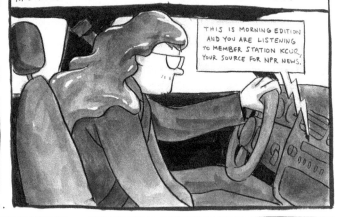

THIS IS MORNING EDITION AND YOU ARE LISTENING to MEMBER STATION KCUR, YOUR SOURCE FOR NPR NEWS.

MAYBE IT'S THE STATE OF THE WORLD.

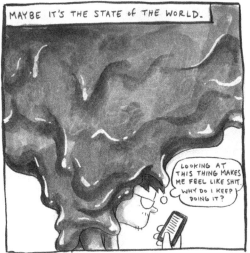

LOOKING AT THIS THING MAKES ME FEEL LIKE SHIT. WHY DO I KEEP DOING IT?

MAYBE IT'S MY JOB.

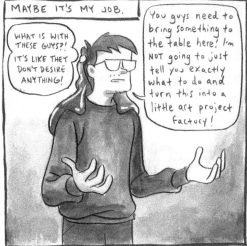

WHAT IS WITH THESE GUYS?! IT'S LIKE THEY DON'T DESIRE ANYTHING!

You guys need to bring something to the table here! I'm NOT going to just tell you exactly what to do and turn this into a little art project factory!

THERE ARE A FEW THINGS I HAVE FOUND THAT HELP ME to SHED THIS FEELING.

GOD! THIS FEELS SO GREAT WHEN I DON'T PLAN IT OUT!

SIP

‹HEFF›
‹HEFF›

I FEEL BEST WHEN I HAVE SOME KIND OF PROJECT to WORK ON, ARTISTIC or OTHERWISE. IN THAT REGARD, OWNING a HOUSE HAS ACTUALLY BEEN PRETTY GOOD for MY MENTAL HEALTH.

What do you think, is this a good height?

Umm...

JUDAH'S BEEN GROWING HIS HAIR OUT for OVER a YEAR NOW, LEADING to AN UNDENIABLE RESEMBLANCE to MY DAD.

JUDAH! GET YOUR HAIR OUT OF YOUR MOUTH!

WHICH IS BOTH SPECIAL and VERY STRANGE.

BUT THEN I WONDER, DOES JUDAH ACTUALLY RESEMBLE MY DAD? OR IS IT THAT OVER TIME, the MEMORY OF MY DAD HAS SLOWLY ABSTRACTED INTO A KIND OF CARTOON? TOUGH GUY. MISCHIEVOUS. LONG BROWN HAIR. BLUE EYES. POINTY NOSE.
I GUESS THIS HAPPENS to ALL OF US EVENTUALLY.

DAVID LIPS
1955 - 1985

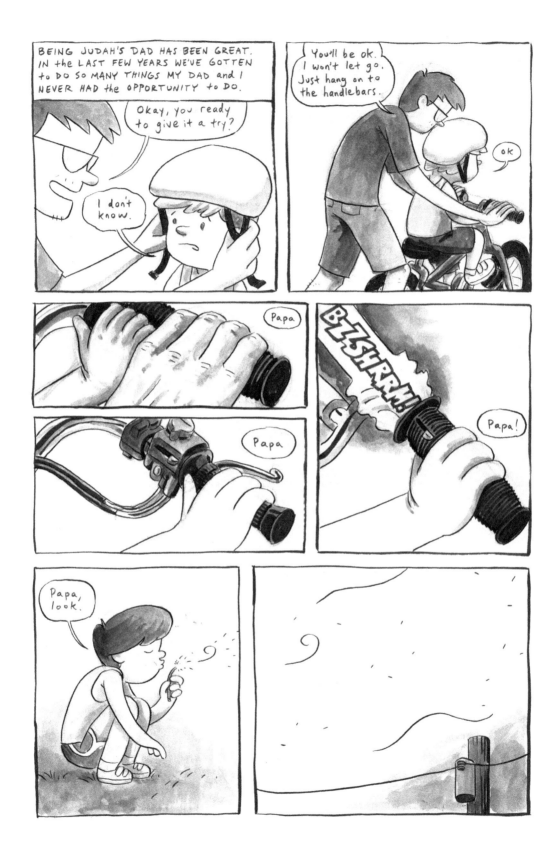

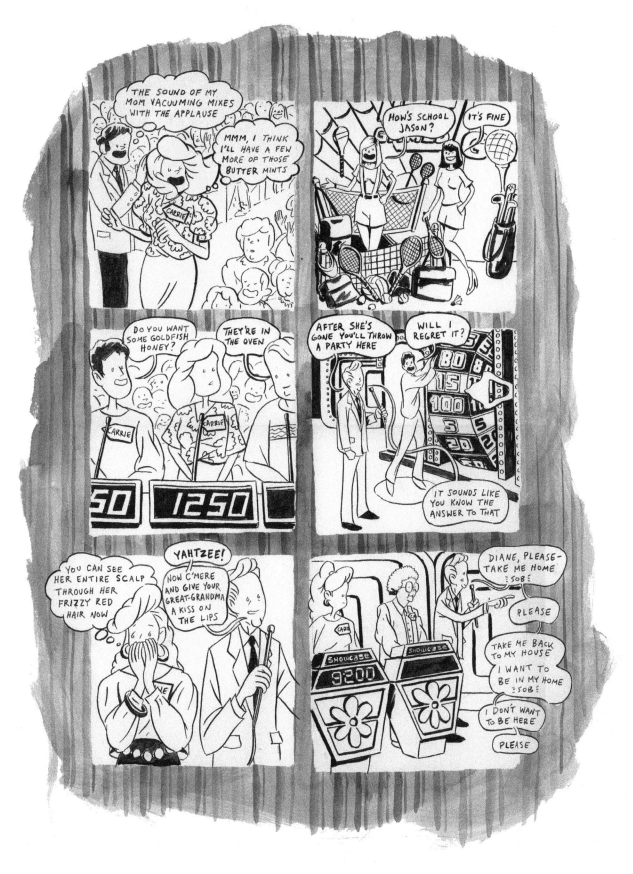

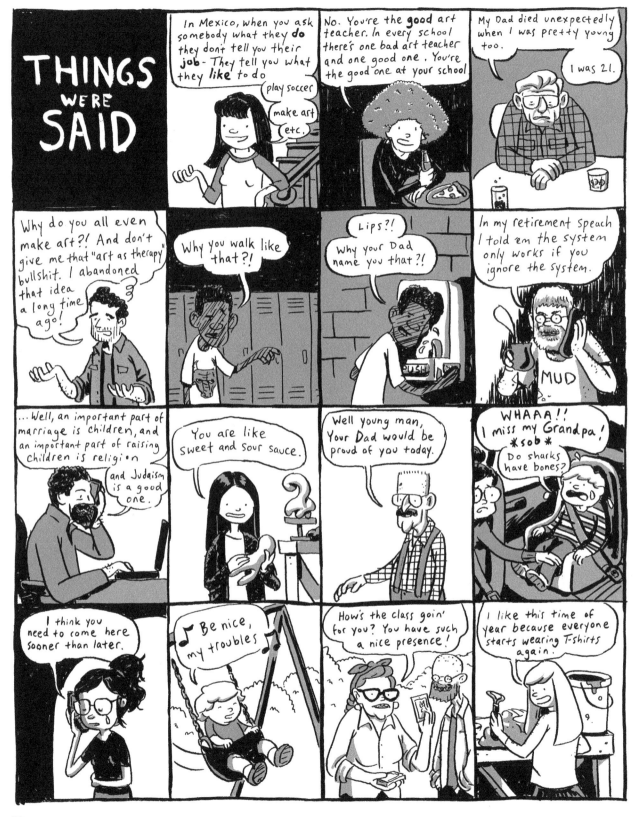

THIS MORNING IN THE SHOWER I NOTICED SOMETHING.

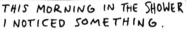
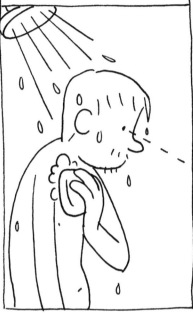

A TINY FACE IN THE TEXTURE OF THE STONE TILES, RIGHT NEXT TO WHERE WE KEEP THE SHAMPOO.

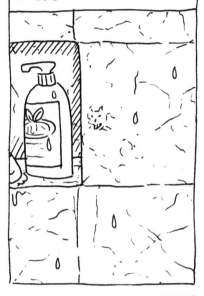

WHO WAS THIS WINKING DEVIL AND WHERE DID HE COME FROM? ME? WAS HE ALWAYS THERE AND WOULD I BE ABLE TO FIND HIM AGAIN? I QUICKLY DREW HIM ON THE STEAMY GLASS. NOW HE IS REAL.

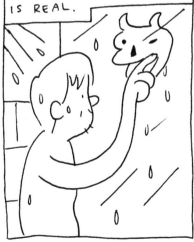

THIS KIND OF THING HAPPENS TO ME A LOT. I FIND CHARACTERS THAT EMERGE FROM WOODGRAIN, FROM MY TOOTHPASTE SWIRLING WITH WATER IN THE SINK. MY SON RECENTLY SAW A CHARACTER IN A PICTURE OF FIRE.

ONCE, WHEN I WAS IN ART SCHOOL, I DROVE TO BLOOMINGTON TO VISIT A GIRL I KNEW IN HIGH SCHOOL. BACK THEN SHE LIVED BY ME SO I USED TO GIVE HER A RIDE TO AND *FROM* SCHOOL EVERYDAY.

SHE WAS A DANCE MAJOR NOW AND I WAS LOOKING FOR... SOMETHING.

HEY! IT'S JASON. IT'S LOOKIN LIKE I'LL BE THERE A LITTLE EARLIER THAN I THOUGHT. MAYBE AROUND ELEVEN.

OKAY I'LL STILL BE AT THE CO-OP BUT YOU CAN LET YOURSELF IN TO MY APARTMENT.

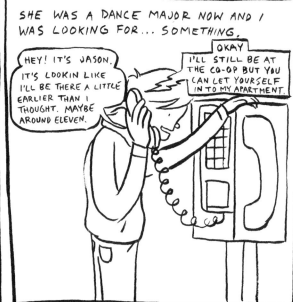

I WAS SO TIRED WHEN I GOT TO HER APARTMENT I THOUGHT I'D JUST TAKE A LITTLE NAP UNTIL SHE GOT HOME FROM WORK.

WOW. SHE REALLY HAS A LOT OF HIPPY STUFF BUT HER PLACE IS REALLY COZY.

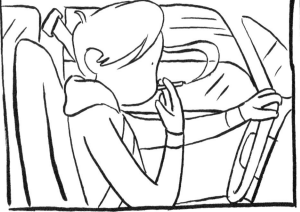

I FELL INTO A DEEP SLEEP IN HER BED, THE WARM SUN FALLING ON MY FACE JUST RIGHT. I EVENTUALLY WOKE UP TO THE HONEYED SOUND OF BILLIE HOLLIDAY ON THE RECORD PLAYER.

Am I blue? Am I

I'VE BEEN CHASING THAT FEELING EVER SINCE.

LAST NIGHT I DREAMT THAT MY MOM
DIED. I WAS DOING MY BEST TO
HOLD IT TOGETHER BUT EVENTUALLY
LOST IT WHILE ORGANIZING HER
FUNERAL AND COLLAPSED ON THE
FLOOR IN TEARS. MY SON LAYED
UPON MY CHEST TO COMFORT ME.

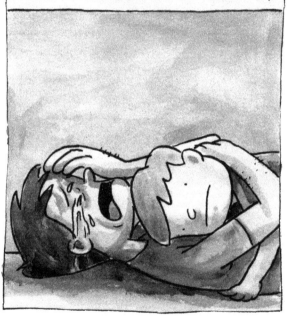

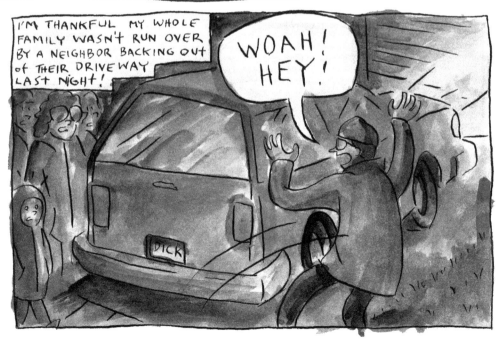

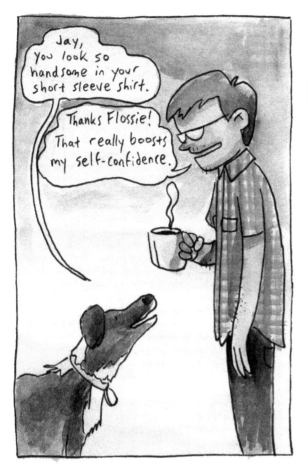

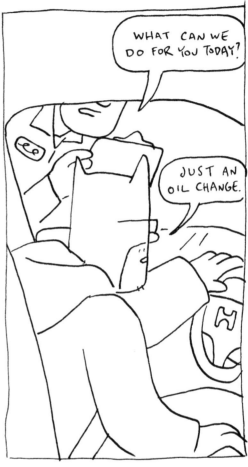

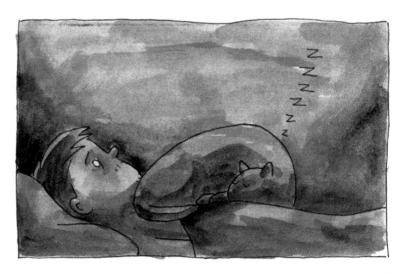

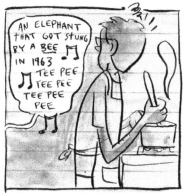

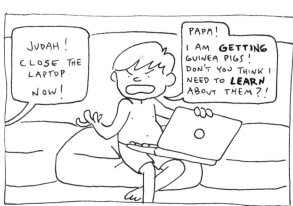

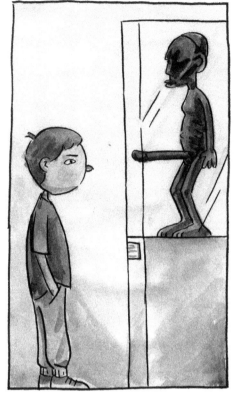

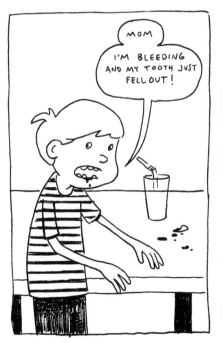

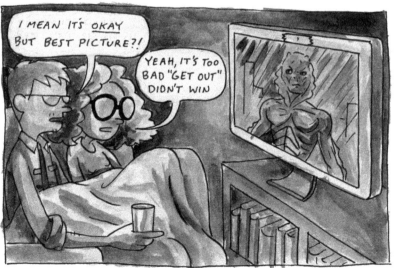

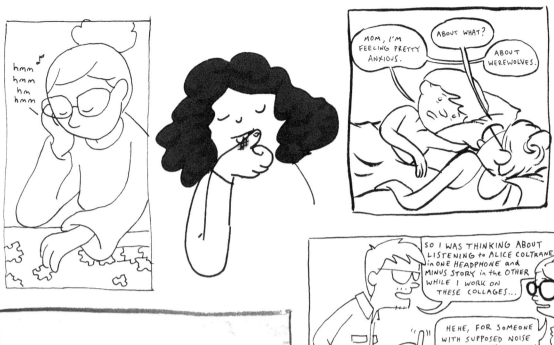

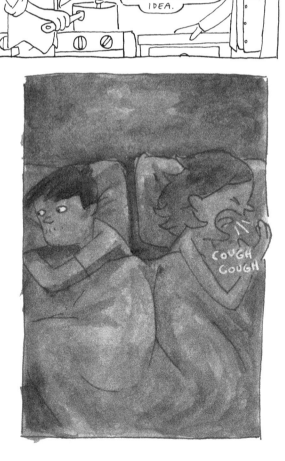

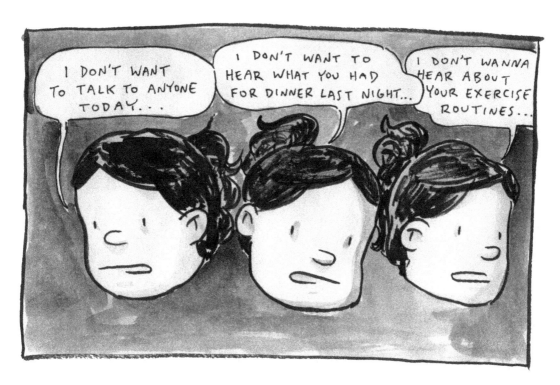

*actual Sun Kil Moon lyrics

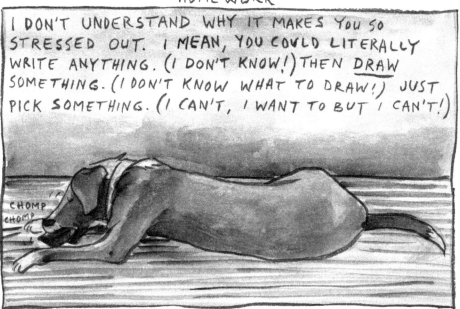

APPARENTLY BY SECOND GRADE, HOMEWORK STRESS IS WELL ESTABLISHED.

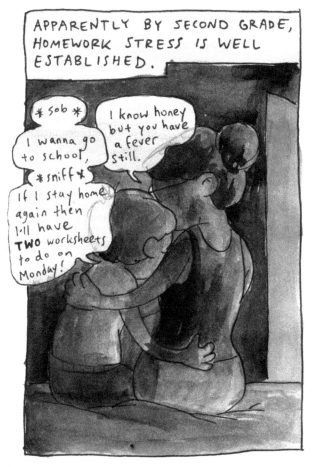

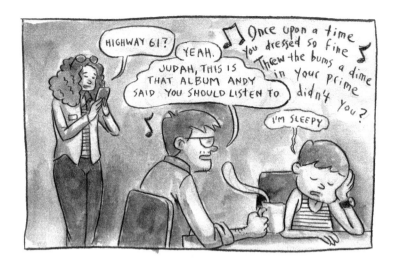

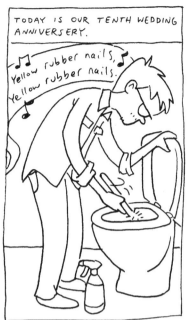

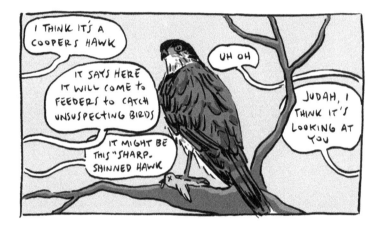

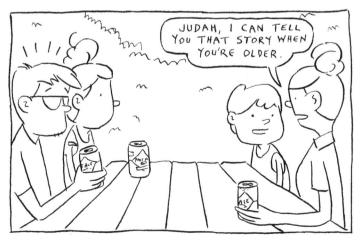

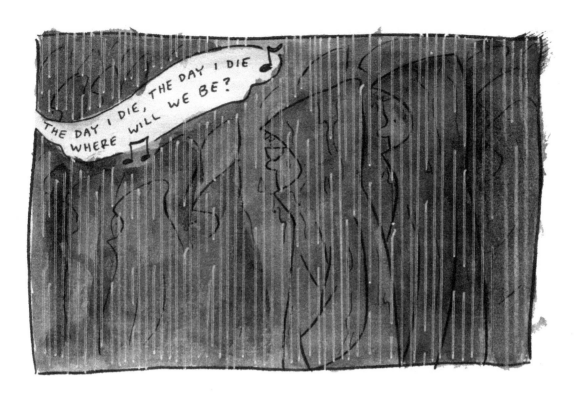

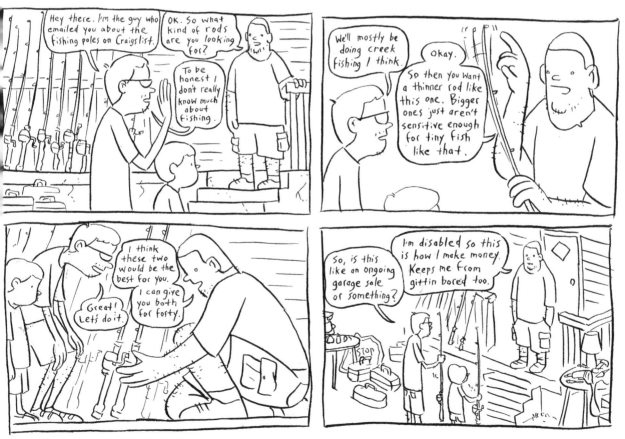

JUDAH WOKE UP IN THE MIDDLE of the NIGHT WITH A MIGRANE. IT WAS TERRIBLE. THERE WAS NOTHING WE COULD DO FOR HIM.

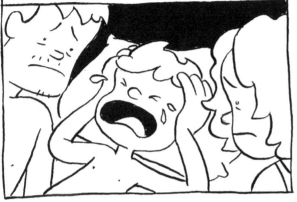

AFTER LYING WITH HIM FOR a few HOURS in HIS BED, HALEY RETURNED to OUR ROOM.

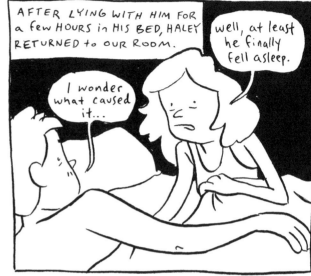

well, at least he finally fell asleep.

I wonder what caused it...

SOME TIME LATER AFTER WE'D FALLEN BACK to SLEEP...

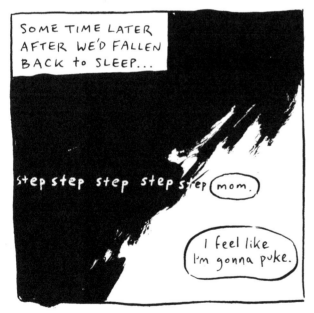

step step step step step mom.

I feel like I'm gonna puke.

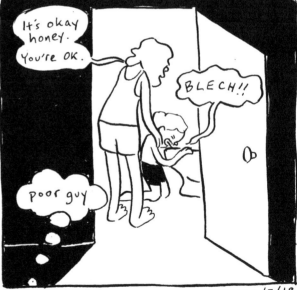

It's okay honey. You're OK.

BLECH!!

poor guy

HAPPENED 5/8/18 DRAWN 6/7/18

BECAUSE OF JUDAH'S RECENT MIGRAINES, HALEY TOOK HIM to the DOCTOR. MY ANXIOUSNESS to HEAR WHAT the DOCTOR thought MADE it DIFFICULT to FOCUS on WORK. HALEY FINALLY TEXTED as I WAS WALKING BACK FROM LUNCH...

BEEP BEEP

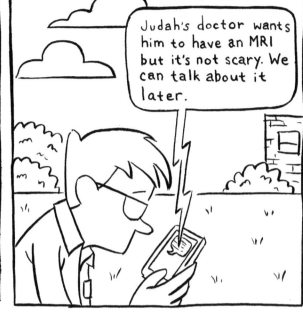

Judah's doctor wants him to have an MRI but it's not scary. We can talk about it later.

I CALLED HALEY IMMEDIATELY.

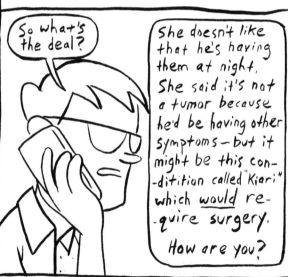

So what's the deal?

She doesn't like that he's having them at night. She said it's not a tumor because he'd be having other symptoms—but it might be this con-ditition called "Kiari" which would re-quire surgery.

How are you?

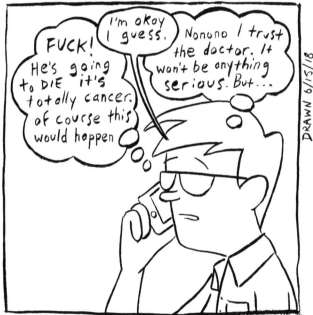

FUCK! He's going to DIE it's totally cancer. of course this would happen

I'm okay I guess.

Nonono I trust the doctor. It won't be anything serious. But...

DRAWN 6/15/18

EDITOR'S NOTE: JUDAH HAD the MRI and EVERYTHING'S totally fine. WHEW!

COFFEE TALK

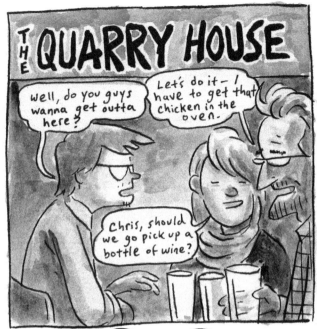

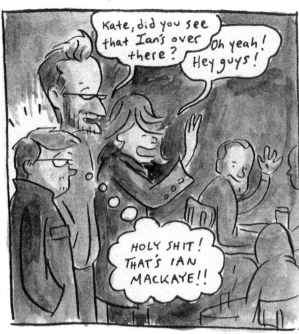

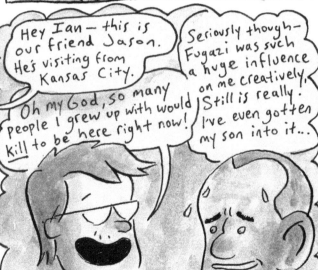

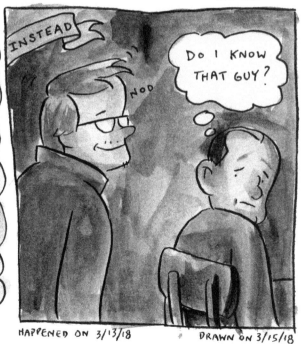

HAPPENED ON 3/13/18 DRAWN ON 3/15/18

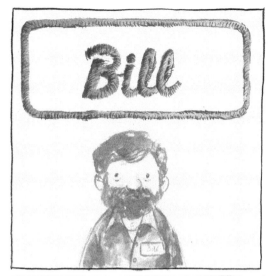

Bill

BILL LIVES WITH US NOW BECAUSE HE'S MY MOM'S BOYFRIEND. WE'VE BEEN PLAYING ZELDA TOGETHER IN THE BASEMENT. BILL HAD THE COOL IDEA OF HOOKING UP A VCR TO THE TV AND NINTENDO SO WE CAN TAPE OURSELVES PLAYING WHEN THE OTHER ONE ISN'T THERE SO THEY DON'T MISS ANYTHING.

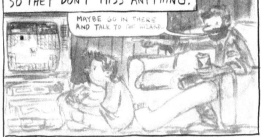

MAYBE GO IN THERE AND TALK TO THE WIZARD.

BILL'S A MECHANIC AT THE TOYOTA DEALER BUT HE'S INTO COMPUTERS AND REMOTE CONTROL PLANES TOO. AND HE'S GOT A MOTORCYCLE BUT HE CAN'T RIDE IT RIGHT NOW BECAUSE OF THE CAST. HIS HANDS ARE ALWAYS BLACK FROM THE CAR GREASE.

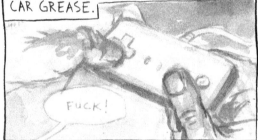

FUCK!

IT'S SUMMER BREAK. MY MOM LEFT ME HOME WITH BILL WHILE SHE AND MY SISTER WENT TO THE STORE. "HEY JASON, WANT TO LEARN HOW TO SHOOT A GUN?"

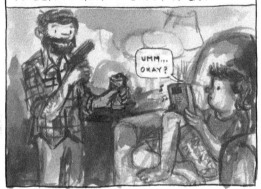

UMM... OKAY?

THE IDEA OF SHOOTING A GUN TERRIFIES ME BUT ALSO SOUNDS COOL. WE WALK SILENTLY THROUGH THE BACKYARD, THE FIELD, AND THROUGH THE FENCE THAT BILL CUT OPEN, INTO THE BRUSH OVERLOOKING THE GRAVEL PIT.

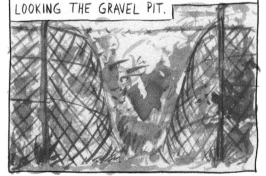

"AH, I SHOULDA HAD YOU PUT PANTS ON, THERE'S POISON IVY ALL OVER BACK HERE. WELL, JUST WATCH OUT, OK?" "I DON'T THINK I'M ALLERGIC TO IT ACTUALLY." "REALLY?!" BILL REPLIED BEFORE TAKING ONE LAST SWIG OF HIS BEER AND CHUCKING THE CAN ONTO THE DRY CLAYBED BELOW. "YOUR DAD COULDN'T EVEN GO NEAR IT!"

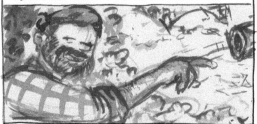

BILL EXPLAINS TO ME HOW THE GUN WORKS, AIMS, AND FIRES, SENDING THE BEER CAN BOUNCING UP IN A CLOUD OF DUST. "YOU GOT IT?" HE SAYS AS HE HANDS ME THE GUN.

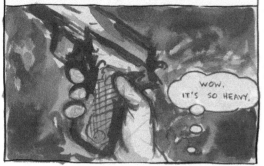

I'M NERVOUS AND KINDA WISH BILL NEVER ASKED ME IF I WANTED TO SHOOT A GUN BUT I DECIDE I'M GONNA GO FOR IT. I PRESS THE BACK OF THE GUN TO MY RIGHT CHEEKBONE, SQUINT DOWN THE BARREL AT THE BEER CAN LYING ON THE GROUND DOWN THE HILL FROM US.

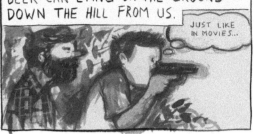

I BARELY SQUEEZE THE TRIGGER BUT IT KICKS BACK HARD RIGHT INTO MY FACE IN A BLINDING PAIN AND I'M NOT EVEN SURE WHAT HAPPENED.

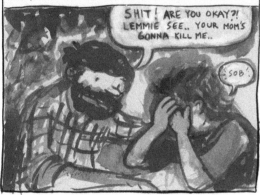

WHEN BILL WAS LITTLE HIS MOM SUPPORTED HIM, HIS BROTHER AND SISTER, AND SO MANY DOGS AND CATS THEY'D ALL LOST COUNT, OFF HER DISABILITY CHECKS AND OCCAS- IONAL MONEY FROM BILL'S FATHER WHEN HE CAME AROUND.

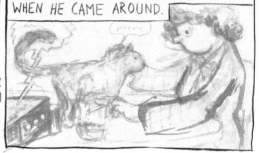

BILLY WAS THE YOUNGEST AND WAS PRETTY MUCH LEFT TO ENTERTAIN HIMSELF. HE SPENT MUCH OF HIS TIME IN THE BASEMENT PUTTING TOGETHER MODEL CARS AND PLANES, HIS LITTLE FINGERS ALWAYS CRUSTED OVER WITH SUPER GLUE.

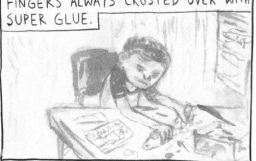

AND BY HIGH SCHOOL HE'D STARTED FIGURING OUT REAL CARS BY FIX- ING UP ALL THE OLD JUNKERS HIS DAD LEFT BEHIND IN THE GAR- AGE AND LITTERED AROUND THE YARD.

"HERE, THIS IS FROM BILL," MY UNCLE GARY SAID, HANDING ME A PLAIN WHITE ENVELOPE. "OH GODDD!" MY MOM, A LITTLE DRUNK, GROANED FROM NEARBY.

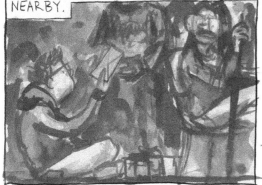

I FORGOT THAT GARY AND BILL WERE FRIENDS. *THE TWO OF THEM USED TO HANG OUT WITH MY DAD BACK BEFORE GARY WENT TO VIETNAM AND BEFORE MY DAD DIED. I HADN'T SEEN BILL FOR A NUMBER OF YEARS SINCE HE AND MY MOM SPLIT UP.*

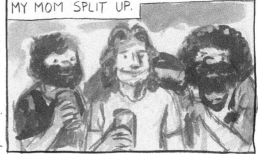

I WAS EXCITED BUT SURPRISED TO GET SOMETHING FROM HIM ON MY BIRTHDAY. MY WHOLE FAMILY SITTING AROUND ME WATCHING, I RIPPED OPEN THE ENVELOPE AND UNFOLDED A PIECE OF PAPER – THE TOP HALF PRINTED WITH A GRAINY PHOTO OF A TOPLESS DARK HAIRED WOMAN. HAND WRITTEN BELOW IT, "HAPPY 12th BIRTHDAY. –BILL"

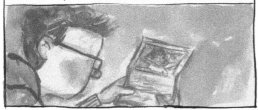

MY FACE FLUSHED SO HOT AND THEN I UNDERSTOOD THAT BILL WAS TRYING TO SIMULTANEOUSLY HELP ME **AND** PISS OFF MY MOM AT THE SAME TIME – WHICH HE DID. IT WAS ACTUALLY PRETTY GENIUS IN A FUCKED UP SORTA WAY. I CAN STILL SEE THAT WOMAN PEERING OUT AT ME FROM THAT PIECE OF PAPER, HER LIPS PARTED JUST SO..

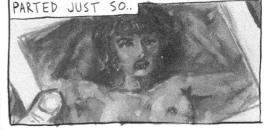

I WAS HOME FROM MY FIRST YEAR OF COLLEGE, VISITING WITH MY GRAND-PARENTS, AND MY COUSIN STACY DROPPED BY TOO **TO** SEE ME.

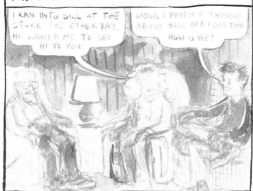

ON MY TENTH BIRTHDAY, BILL TOOK ME ON A LONG RIDE ON THE HIGHWAY ON THE BACK OF HIS MOTORCYCLE. HE RIGGED UP OUR HELMETS WITH MICROPHONES SO WE COULD TALK THE WHOLE TIME.

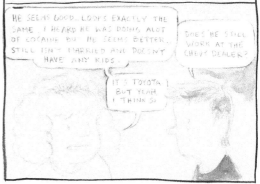

I WAKE UP AND TELL HALEY ABOUT A DREAM I HAD IN WHICH JUDAH AND I WERE RUMAGING THROUGH BOXES IN A BUSY WAREHOUSE OF ANTIQUES.

...AND I HEARD A MUFFLED VOICE COMING FROM MY POCKET AND I REALIZED I BUTT DIALED SOME RANDOM NUMBER. SO I SAID, "HELLO. WHO IS THIS?" AND A MAN'S VOICE I RECOGNIZED FROM SOMEWHERE DEEP IN MY MEMORY REPLIED, "BILL." "WAIT, BILL NEMETH?!" I ASKED. "YES"

WHAT ARE THE ODDS THAT THIS RANDOM COMBINATION OF NUMBERS WOULD CONNECT TO SOMEBODY FROM MY PAST? BILL AND I CAUGHT UP ON THE LAST FEW DECADES OF OUR LIVES BUT IT WAS VERY HARD TO HEAR HIM OVER THE NOISE OF THE WAREHOUSE.

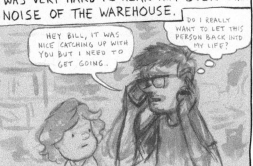

HEY BILL, IT WAS NICE CATCHING UP WITH YOU BUT I NEED TO GET GOING.

DO I REALLY WANT TO LET THIS PERSON BACK INTO MY LIFE?

"JASON.." I HEAR SOMEBODY SAY MY NAME FROM BEHIND. I TURN AROUND AND KNOW IT'S HIM. HE'S TALLER THAN I RECALL. HOW DID HE KNOW WHERE I WAS? I KNOW IN THAT MOMENT THAT I WILL NEVER BE FREE OF HIM NOW.

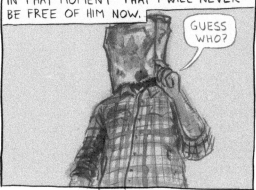

GUESS WHO?

BILL LIVES ALONE IN HIS CHILDHOOD HOME, HIS MOM GONE FOR MANY YEARS. SIBLINGS GOT THEIR OWN THINGS GOING ON. NO CATS EVEN.

DING

BILL

HE EATS MOST OF HIS MEALS IN FRONT OF HIS COMPUTER IN THE BASEMENT, SITTING AT THE SAME TABLE WHERE HE USED TO BUILD HIS MODELS AS A KID.

CAN YOU THINK OF ANYBODY YOU KNOW WHO IT WOULDN'T SURPRISE YOU TO LEARN THEY WERE PART OF THE MOB THAT STORMED THE CAPITOL?

HMM, I DON'T KNOW...HOW ABOUT YOU?

WELL, IT WOULDN'T SURPRISE ME AT ALL IF SOME PEOPLE FROM HIGH SCHOOL FELL INTO ALL THAT..

WOULD BILL HAVE FALEN FOR ALL THAT TRUMP CRAP? I DON'T REMEMBER HIM BEING ALL THAT POLITICAL.. OR RACIST. BUT HE WAS INTO THE INTERNET AND HIS GUNS...NAH, I DON'T THINK SO.

OK.. YOU READY, BUDDY ?

YEP.

ALRIGHT.. JUST MAKE SURE YOU KEEP HANGIN' ON TO ME..

.. HERE WE GO..

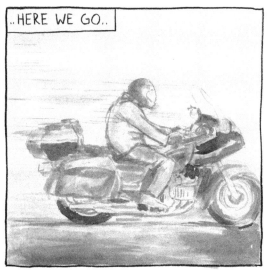

SUMMER IS HERE AGAIN. NEXT YEAR I'LL BE IN FIFTH GRADE. BILL COMES AND SITS DOWN NEXT TO ME ON THE COUCH. SOMETHING SEEMS WEIRD. "WHATCHA DRAWIN' BUDDY?" I WONDER WHERE MY MOM IS..

LOOKS PRETTY COOL..

UM.. IT'S THIS NEW SUPERHERO CALLED SPAWN.

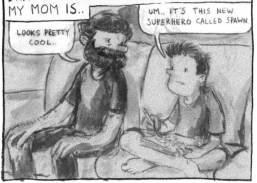

SO, LISTEN JASON.. I WANTED TO TELL YOU THAT I'M GOING TO BE MOVING OUT.

...

WHY?

WELL, YOUR MOM AND I JUST HAVEN'T BEEN GETTING ALONG VERY WELL LATELY.

MY WHOLE FACE FEELS ALL TIGHT AND CRUMPLED UP. I SWALLOW. I DON'T REALLY UNDERSTAND BUT I CAN TELL THIS IS HARD FOR BILL TOO.

OK

I STARE AT MY DRAWING, OUT THE WINDOW, ANYWHERE BUT AT BILL. WHERE IS MY MOM? WHEN WILL SHE BE HOME?

OKAY BUDDY.. I'LL SEE YOU LATER THEN..

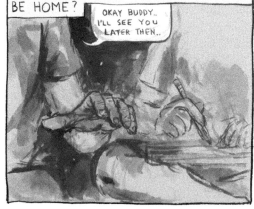

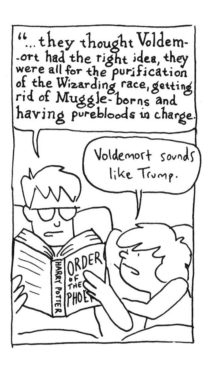

DON'T LOOK AT THE NEWS. DON'T LOOK AT THE NEWS.

WAIT. IF I'M NOT LOOKING AT THE NEWS WHY AM I EVEN LOOKING AT THIS THING AT ALL?!

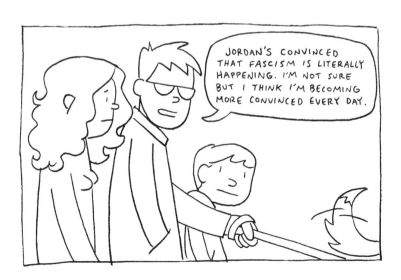

JORDAN'S CONVINCED THAT FASCISM IS LITERALLY HAPPENING. I'M NOT SURE BUT I THINK I'M BECOMING MORE CONVINCED EVERY DAY.

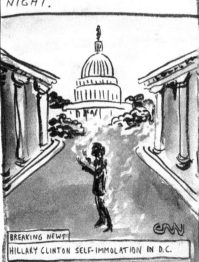

GOING TO BED WITH MID-TERM ELECTION ANXIETY **GAVE ME** VERY STRANGE DREAMS LAST NIGHT.

BREAKING NEWS
HILLARY CLINTON SELF-IMMOLATION IN D.C.

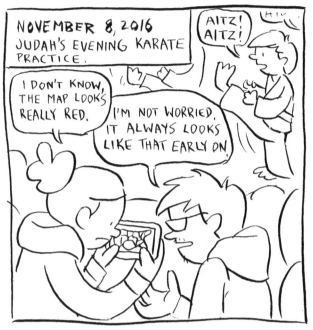

NOVEMBER 8, 2016
JUDAH'S EVENING KARATE PRACTICE.

AITZ! AITZ!

I DON'T KNOW, THE MAP LOOKS REALLY RED.

I'M NOT WORRIED. IT ALWAYS LOOKS LIKE THAT EARLY ON.

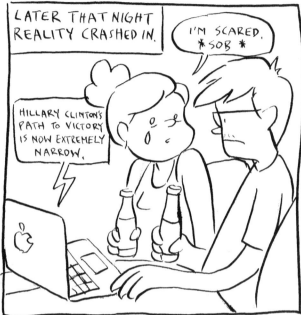

LATER THAT NIGHT REALITY CRASHED IN.

I'M SCARED. *SOB*

HILLARY CLINTON'S PATH TO VICTORY IS NOW EXTREMELY NARROW.

THE NEXT MORNING WE HAD A PARENT-TEACHER CONFERENCE AT OUR SON'S SCHOOL. WE WERE A WRECK. WHILE WAITING IN THE HALL WE RAN INTO SOME OF THE WEALTHIER PARENTS.

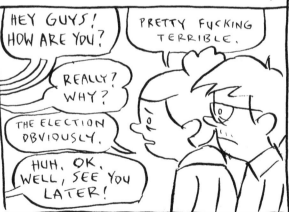

HEY GUYS! HOW ARE YOU?

PRETTY FUCKING TERRIBLE.

REALLY? WHY?

THE ELECTION OBVIOUSLY.

HUH, OK, WELL, SEE YOU LATER!

I STILL WONDER IF THEY VOTED FOR HIM. AND WITH TWO DAUGHTERS! MAYBE IT'S JUST THAT THEY'RE SO RICH THAT THEY'RE UNAFFECTED EITHER WAY.

WILL THEY VOTE FOR HIM AGAIN?

...WITH 2020 VOTING SET TO BEGIN, A CONVERSATION ABOUT THE LESSONS OF 2016. THIS IS — THE DAILY.

1/31/20

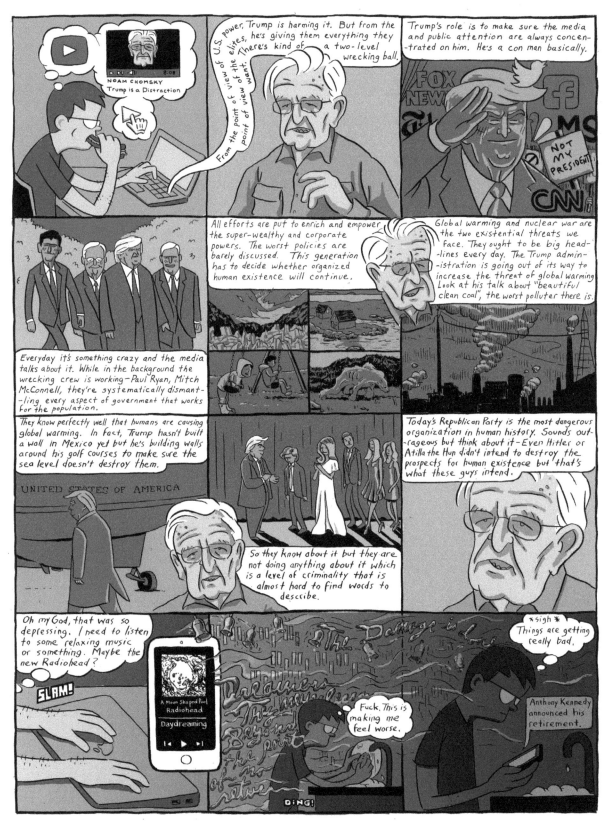

4:30 AM

LAST NIGHT I DREAMT THERE WERE NOW ARMED CIVILIANS, ALL LARGE WHITE MEN, CONDUCTING "RANDOM" TRAFFIC STOPS.

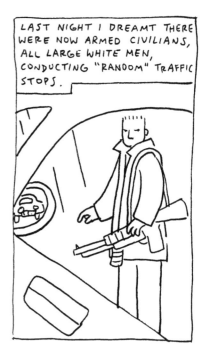

ANXIETY DREAMS

I HAD EXACTLY TWO ANXIETY DREAMS LAST NIGHT ABOUT JOBS I'VE HAD.

IN THE FIRST I WAS SHOWING MY ART STUDENTS A DOCUMENTARY ABOUT MEXICAN FOLK ART.

BLAH BLAH BLAH

ONLY WE WERE ALL IN MY CHILDHOOD CLOSET

IN THE SECOND I WAS BACK AT AN OLD COFFEE SHOP JOB.

WHAT'RE YOU DOING?! DON'T PRESS THAT!

I HAVE THIS SPECIFIC DREAM OFTEN.

HOW CAN I STOP HAVING THESE DREAMS? THERAPY? MEDITATION? MAYBE I SHOULD STOP DRINKING COFFEE?

BEEP! BEEP! BEEP!

I DREAMT I SAW A MAN WHO WAS FILTHY AND HAD TWO SMALL WHITE WORMS CRAWLING IN HIS HAIR BEHIND HIS EAR.

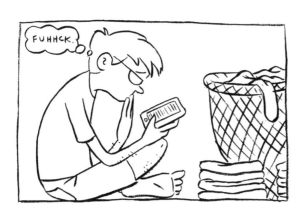

FUHHCK.

THE WALLPAPER IN THE KITCHEN WAS PEELING BADLY.

IF I MINCE UP ALL THESE DEAD FLIES FROM THE VENTILATION FAN AND ADD THEM TO THE RICE NOONE WILL EVEN NOTICE.

GOOD PROTEIN

I WONDER IF I SHOULD ROAST THE GRASSHOPPERS BEFORE I ADD THEM?

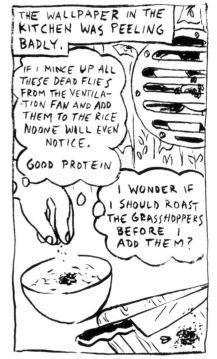

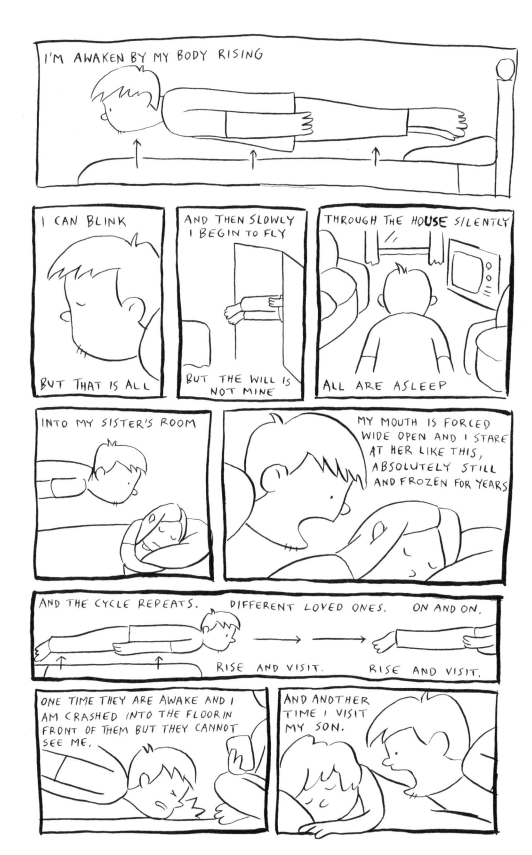

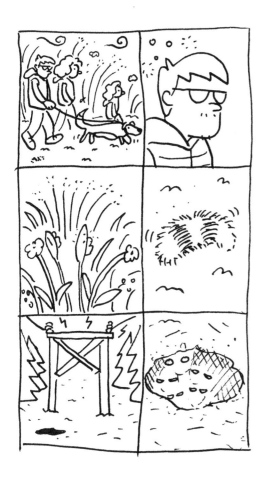

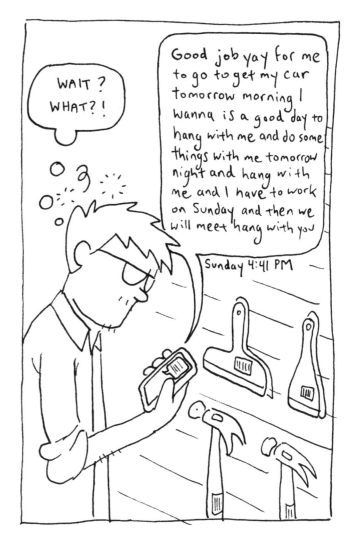

WAIT? WHAT?!

Good job yay for me to go to get my car tomorrow morning I wanna is a good day to hang with me and do some things with me tomorrow night and hang with me and I have to work on Sunday and then we will meet hang with you

Sunday 4:41 PM

UGH, WHY DO PEOPLE LIKE THIS FEELING?

COLD MEDICINE

JASON LIPS © 2018

I WAS IN A DEEP SLEEP DUE TO THE FULL DOSE OF COLD MEDICINE I'D TAKEN. I WAS PULLED OUT OF A VERY STRANGE DREAM BY THAT SOUND THAT EVERY CAT OWNER KNOWS.

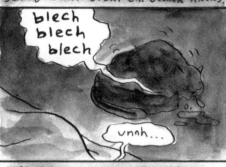

RIGHT BEFORE WE WENT TO BED I NOTED HOW KEVIN HADN'T PUKED IN A WHILE. HE IS 17 AND HIS KIDNEYS ARE FAILING. IT'S ONLY A MATTER OF TIME.

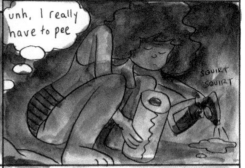

I SHUFFLED MY WAY TO THE BATHROOM AND JUST STOOD THERE FOR A BIT, TOO ASLEEP TO EVEN PEE I GUESS.

I STARTED TO FEEL A BIT UNSTEADY, LIKE I MIGHT COLLAPSE.

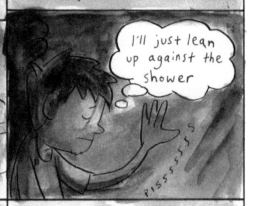

THEN MY VISION WAS FILLED WITH RED, YELLOW, AND BLUE "SPRINKLES." I'M NOT SURE IF MY EYES WERE OPEN OR CLOSED.

COLLAPSING BACK INTO BED, THE SPRINKLES AND A WEIRD HUM CONTINUED FOR A MOMENT OR TWO AND THEN I FELL BACK ASLEEP.

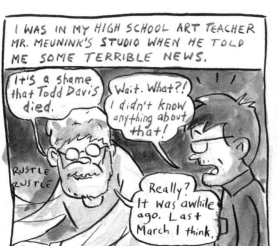

I WAS IN MY HIGH SCHOOL ART TEACHER MR. MEUNINK'S STUDIO WHEN HE TOLD ME SOME TERRIBLE NEWS.

It's a shame that Todd Davis died.

Wait. What?! I didn't know anything about that!

RUSTLE RUSTLE

Really? It was awhile ago. Last March I think.

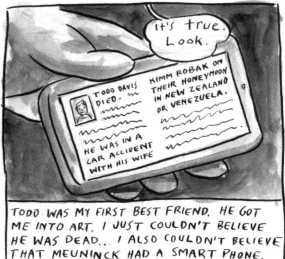

It's true. Look.

TODD DAVIS DIED.

KIMM ROBAK ON THEIR HONEYMOON IN NEW ZEALAND OR VENEZUELA.

HE WAS IN A CAR ACCIDENT WITH HIS WIFE

TODD WAS MY FIRST BEST FRIEND. HE GOT ME INTO ART. I JUST COULDN'T BELIEVE HE WAS DEAD... I ALSO COULDN'T BELIEVE THAT MEUNINCK HAD A SMART PHONE.

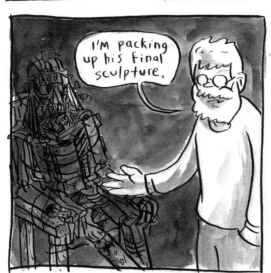

I'm packing up his final sculpture.

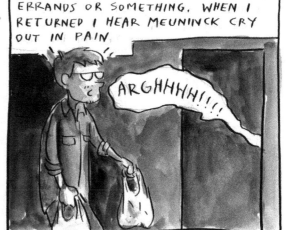

I LEFT FOR AWHILE TO RUN SOME ERRANDS OR SOMETHING. WHEN I RETURNED I HEAR MEUNINCK CRY OUT IN PAIN

ARGHHHH!!!!

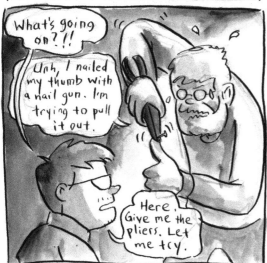

What's going on?!!

Unh, I nailed my thumb with a nail gun. I'm trying to pull it out.

Here. Give me the pliers. Let me try.

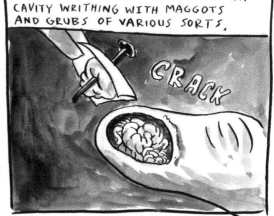

I PULLED SO HARD HIS ENTIRE THUMBNAIL CAME OFF TAKING A CHUNK OF FLESH WITH IT. BENEATH IT WAS A DARK CAVITY WRITHING WITH MAGGOTS AND GRUBS OF VARIOUS SORTS.

CRACK

DREAMT 9/23/18

LAST NIGHT I DREAMT THAT A WITCH WAS TRYING to DESTROY ME and a COUPLE of FRIENDS I HAVEN'T SEEN in awhile. THEN ONE of the FRIENDS gave me AN IMPORTANT GIFT.

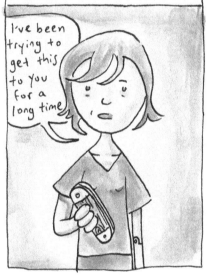

I've been trying to get this to you for a long time

I LOOKED OUT MY STUDIO WINDOW AND SAW THAT the TREE MAN HAD ARRIVED.

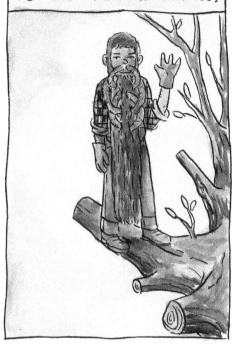

HEY, WAKE UP YOU'RE HAVING A NIGHTMARE

NNHH, NO

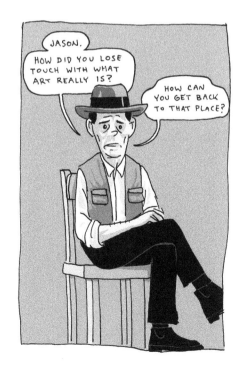

JASON.

HOW DID YOU LOSE TOUCH WITH WHAT ART REALLY IS?

HOW CAN YOU GET BACK TO THAT PLACE?

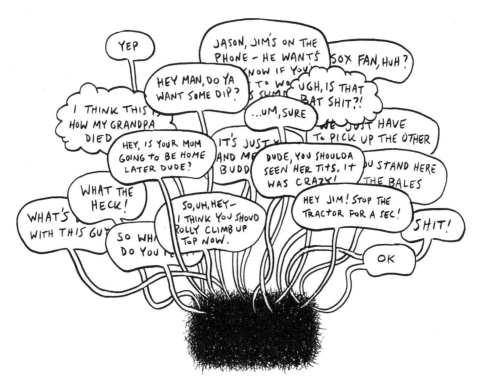

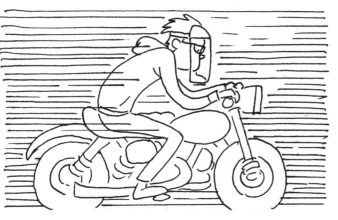

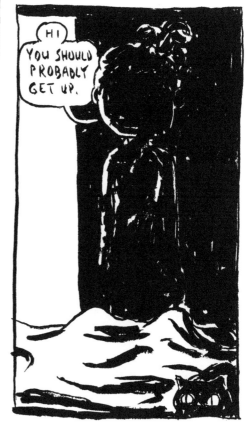

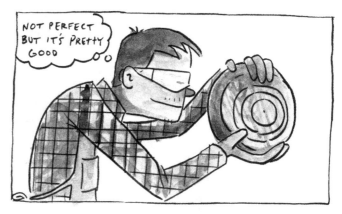

NOT PERFECT BUT IT'S PRETTY GOOD

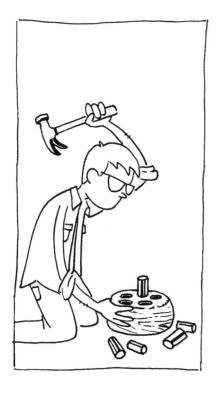

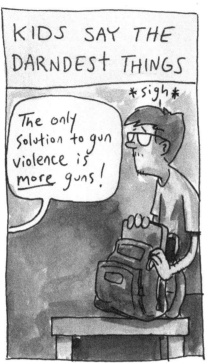

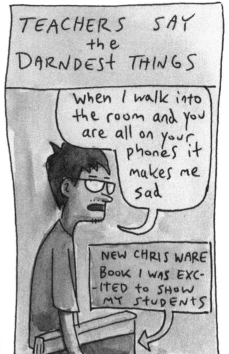

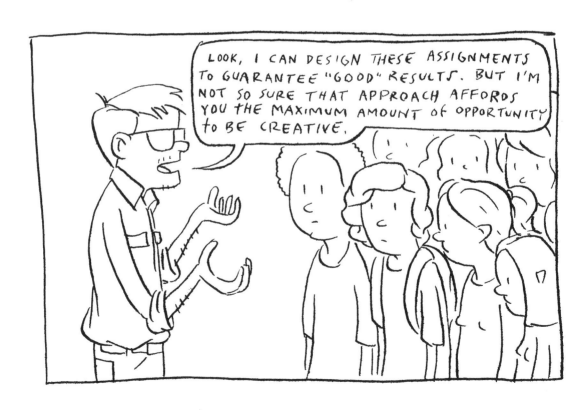

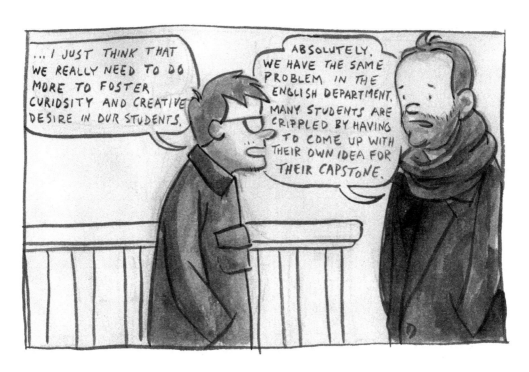

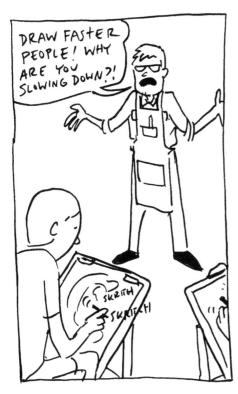

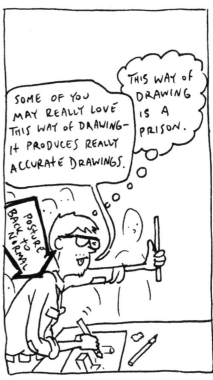

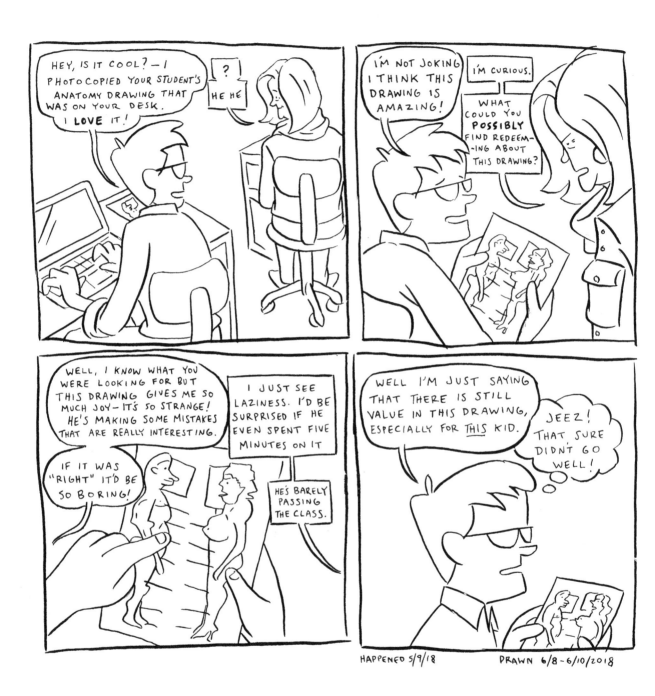

ART EDUCATORS OFTEN MIS-APPLY OR JUST PLAIN IGNORE SURREALIST APPROACHES, FAVORING INSTEAD A METHODICAL, RATIONAL APPROACH DERRIVED FROM THE WESTERN CLASSICAL AND RENAISSANCE ACADAMIES.

> IT'S A NICE DRAWING BUT WHAT IS YOUR INTENDED MESSAGE? AND I NEED TO SEE MORE PREPARATORY SKETCHES AND APPROVE THEM BEFORE YOU CAN ADVANCE TO THE REAL DRAWING. WAH WAH WAH WAH WAH . . .

THERE ARE MANY REASONS ART TEACHERS TAKE THIS APPROACH: A DESIRE TO BE TAKEN SERIOUSLY BY ADMINISTRATORS and THEIR MORE "ACADEMIC" COLLEAGUES; A SEARCH FOR SOMETHING THAT CAN BE GRADED "OBJECTIVELY", A DESIRE to HOLD STUDENTS ACCOUNTABLE; AND JUST PLAIN IGNORANCE OF HOW CREATIVITY HAPPENS NOW and IN THE PAST.

> I MISS WHEN ART CLASS WAS FUN. I DON'T EVEN WANT TO MAKE ART ANYMORE.

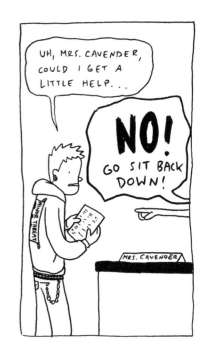

> UH, MRS. CAVENDER, COULD I GET A LITTLE HELP . . .

> NO! GO SIT BACK DOWN!

MRS. CAVENDER

EVEN THE RENAISSANCE MASTER LEONARDO da VINCI ADVOCATED SURREALIST PRACTICES, CENTURIES BEFORE ANDRE BRETON WOULD COIN THE TERM AND WRITE "THE SURREALIST MANIFESTO".

> LOOK at WALLS SPLASHED WITH a NUMBER of STAINS, OR STONES OF VARIOUS MIXED COLORS. IF YOU HAVE TO INVENT SOME SCENE, YOU CAN SEE THERE RESEMBLANCES to a NUMBER of LANDSCAPES ADORNED WITH MOUNTAINS, RIVERS, ROCKS, TREES, GREAT PLAINS, VALLEYS AND HILLS IN VARIOUS WAYS.

IT IS TIME FOR ART TEACHERS to ACKNOWLEDGE THAT MUCH ART SINCE the EARLY 20th CENTURY (OR MUCH, MUCH EARLIER) IS ENABLED BY SURREALIST (and DADA) TACTICS and UPDATE OUR APPROACHES. WE CAN'T TEACH LIKE ART ENDED WITH the 19th CENTURY!

> I'M NOT GOING to LET THIS TEACHER RUIN MY LOVE OF ART. FUCK THAT! I'LL DRAW WHATEVER I WANT, HOWEVER I WANT!

scritch scritch

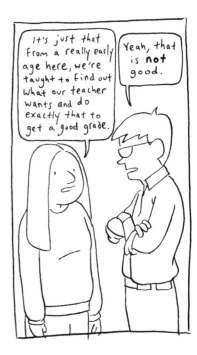

> It's just that from a really early age here, we're taught to find out what our teacher wants and do exactly that to get a good grade.

> Yeah, that is **not** good.

79

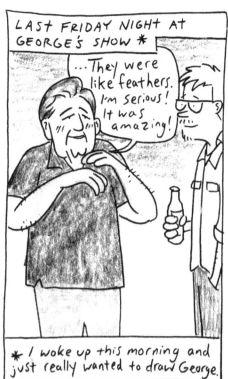

LAST FRIDAY NIGHT AT GEORGE'S SHOW *

...They were like feathers. I'm serious! It was amazing!

* I woke up this morning and just really wanted to draw George.

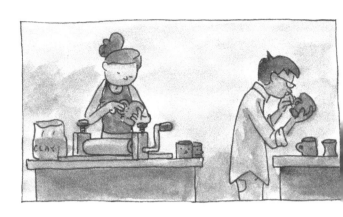

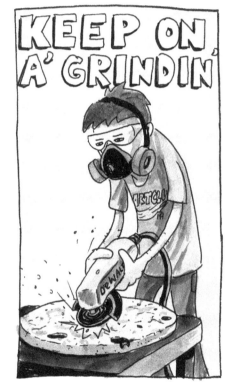

KEEP ON A' GRINDIN'

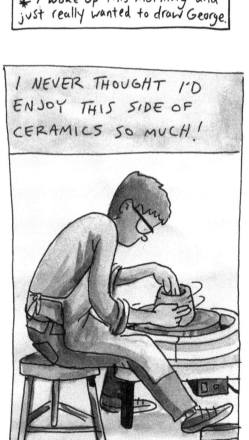

I NEVER THOUGHT I'D ENJOY THIS SIDE OF CERAMICS SO MUCH!

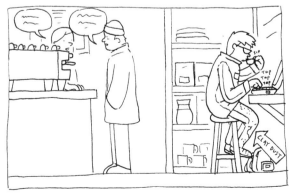

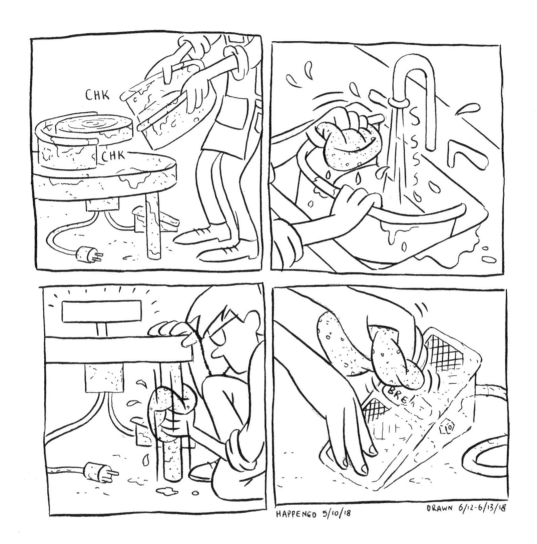

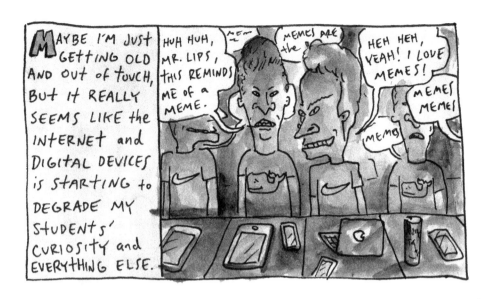

I'VE PROCTORED MANY FINAL EXAMS OVER THE YEARS HERE SO I KNOW YOU ARE CAPABLE OF QUIETLY FOCUSING ON A SINGLE ACTIVITY FOR AN HOUR OR MORE. SO WHEN YOU WON'T QUIETLY FOCUS ON YOUR DRAWING FOR EVEN FIVE MINUTES, THAT TELLS ME EITHER YOU SIMPLY DON'T GIVE A SHIT, YOU DON'T TRUST ME THAT THERE MIGHT BE SOMETHING FOR YOU IN THIS PROCESS, OR THAT YOU WILL ONLY FOCUS QUIETLY IF THERE IS THE OVERT THREAT OF PUNISHMENT OR A BAD GRADE AND THAT MAKES ME SAD.

TODAY I RE-READ ALL OF LYNDA BARRY'S GREAT BOOK "WHAT IT IS" ON THE FLIGHT TO SAN DIEGO. I HOPE I CAN IN-SPIRE MY STUDENTS EVEN HALF AS MUCH AS SHE HAS INSPIRED ME.

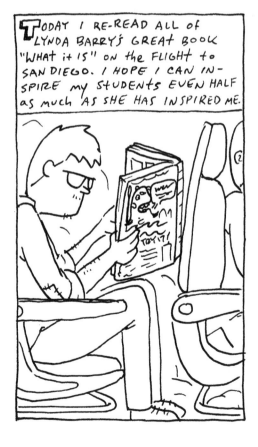

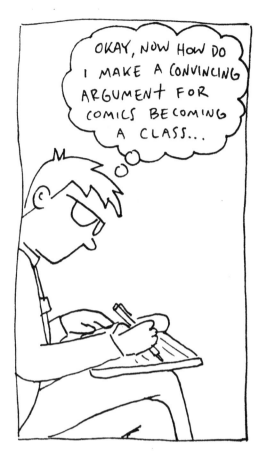

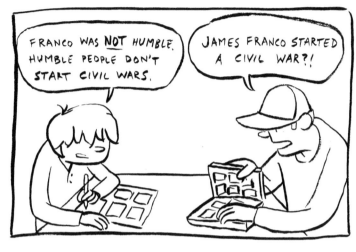

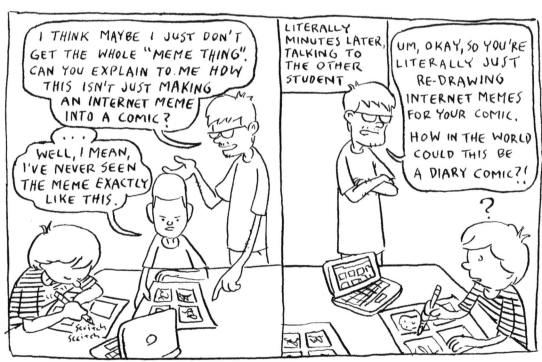

OFTEN, WHEN I TELL PEOPLE I'M A TEACHER THEY SAY, "OH MY GOD, YOU'RE SO LUCKY to HAVE SO MUCH TIME off WORK— IS It GREAT?"

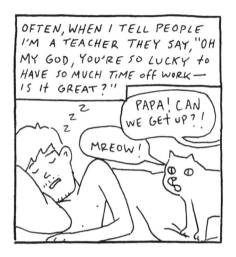

I'M NOT COMPLAINING, BUT its JUST NOT that SIMPLE. FOR ME It's REALLY HARD to JUST TURN it OFF, GO RIGHT from TEACHER MODE to VACATION MODE, FAMILY MODE, ARtIST MODE.

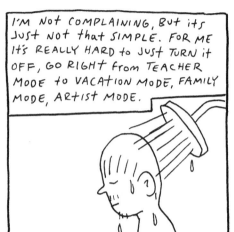

I FIND the FIRST FEW DAYS of a BREAK is WHEN I HAVE ALL MY BESt IDEAS about TEACHING, MY MIND RACING, THINKING ABOUt all the THINGS I DID POORLY this SEMESTER and ALL these REALIZATIONS ABOUt HOW to DO it BETTER NEXt tIME AROUND.

TODAY'S MY FIRST DAY of WINTER BREAK. I WONDER HOW I'LL SPEND IT?

IN THE SHOWER I DISCOVERED A NEW WAY OF DRAWING EYES IN ONE SIMPLE STROKE THAT FEELS LIKE MAGIC.

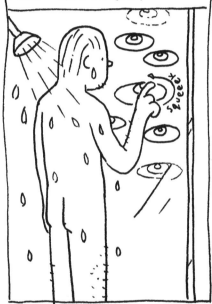

IT'S JUST LIKE THE UPTURNED EYES YOU SEE ON THE GODS IN ANCIENT SOUTH AMERICAN ART.

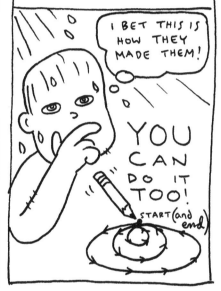

WE WENT TO GO SEE the MUSICAL ADAPTATION of ALLISON BECHDEL'S "FUN HOME" at the LOCAL THEATRE.

LOOK, YOU CAN SEE A COFFIN IN the NEXT ROOM BECAUSE THEY RUN A FUNERAL HOME.

GRAMMA, WHEN'S IT GONNA START?

THE PLAY WAS ABSOLUTELY AMAZING. FROM HOW THERE WERE the THREE ALLISONS, to HOW THEY MADE "PANEL BORDERS" WITH NEON LIGHTS — THE PERFORMANCES, the DAD'S SUICIDE, ALL SO POWERFUL!

♪ I'M CHANGING MY MAJOR to JOAN! ♪

I FOUND MYSELF ON THE EDGE OF TEARS THROUGH the ENTIRE PLAY. I ALWAYS FEEL MOVED WHEN I SEE LIVE PERFORMANCES, BUT THIS WAS SOMETHING ELSE.

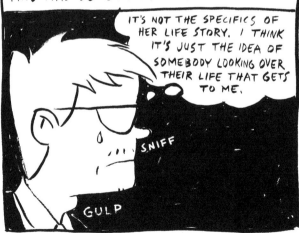

IT'S NOT THE SPECIFICS OF HER LIFE STORY. I THINK IT'S JUST THE IDEA OF SOMEBODY LOOKING OVER THEIR LIFE THAT GETS TO ME.

SNIFF

GULP

BY the END I REALIZED THAT I HAD COME TO FULLY BELIEVE THAT the "ADULT ALLISON" WAS the REAL ALLISON BECHDEL.

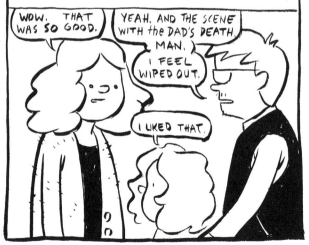

WOW. THAT WAS SO GOOD.

YEAH. AND THE SCENE WITH the DAD'S DEATH. MAN. I FEEL WIPED OUT.

I LIKED THAT.

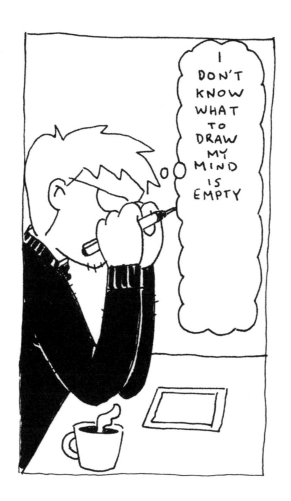

TEACHING ART REMOTELY DURING THE QUARANTINE HAS BEEN **WAY** HARDER THAN I THOUGHT IT WOULD BE.

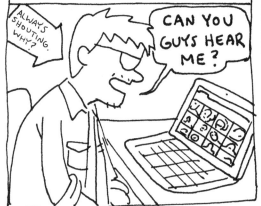

ALWAYS SHOUTING. WHY?

CAN YOU GUYS HEAR ME?

SEEING ECHOS WITH THE PAST, and SINCE the STUDENTS DON'T HAVE ART SUPPLIES, I'VE TRIED to INTRODUCE THEM to DADA, FLUXUS, and CONCEPT-UAL ART.

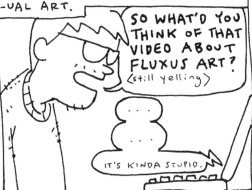

SO WHAT'D YOU THINK OF THAT VIDEO ABOUT FLUXUS ART? (still yelling)

. . .

IT'S KINDA STUPID.

THE WORST PART OF REGULAR CLASS-ROOM TEACHING TO ME IS FEELING LIKE I'M TALKING TO A ROOM OF BLANK STARES. WITH FROZEN VIDEO, GARBLED AUDIO, and SLUGGISH INTERNET, THAT FEELING IS NOW CONSTANT.

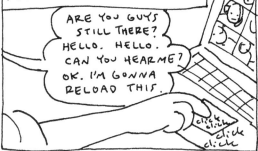

ARE YOU GUYS STILL THERE? HELLO. HELLO. CAN YOU HEAR ME? OK. I'M GONNA RELOAD THIS.

click click click click

WHILE IT HAS BEEN NICE to SEE MY STUDENTS' FACES, I'VE HAD TO CON-FRONT the FACT THAT WE'RE JUST NOT GOING to EVEN REMOTELY FEEL LIKE WE'RE TOGETHER. IT'S MUCH MORE LIKE a DYSTOPIAN ART CORRESPONDANCE COURSE.

JESUS. I'VE ONLY "TAUGHT" FOR 25 MINUTES AND IT FEELS LIKE 10 HOURS!

AT THE END OF THE DAY, ALL I REALLY HAVE ENERGY FOR IS DRINKING BEER and WATCHING "TIGER KING".

OH MY GOD. THIS IS SO DEPRESSING. I'M NOT SURE HOW MUCH MORE I CAN TAKE.

BUT ON FRIDAY THREE OF MY CLASSES WILL BE RECORDING PERF-ORMANCES OF JOHN CAGE'S "4'33" USING WHATEVER INSTRUMENTS WE ALL HAVE. I'M HOPING IT WILL BE FUN and ENERGIZE THEM ABOUT this NEW WAY OF THINKING ABOUT and MAKING ART.

VOICE NEARLY SHOT

TEXTING ABOUT ALL OF THIS WITH MY GOOD FRIEND EMILY YATES.

4/1/20

HEADING EAST ON K-10, FROM LAWRENCE TO KANSAS CITY.

QUARANTINE PARENTING

MAZIN! MAZIN! NO! MAZIN, NO, I DON'T HAVE ANY STONE. FOR WHAT? ARGH! I JUST DIED. YES! OK. HEHE. OK. OK. OK. MAZIN, DO YOU WANT TO BUILD A NEW HOUSE? I'M JUST MAKIN ALL THESE TREES INTO CHARCOAL. OOH! I GOT AN ACHIEVEMENT. I'M NOT GOING TO KILL YOU MAZIN!

TAP TAP TAP

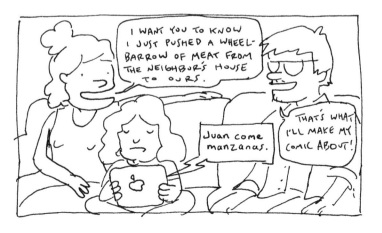

I WANT YOU TO KNOW I JUST PUSHED A WHEELBARROW OF MEAT FROM THE NEIGHBOR'S HOUSE TO OURS.

Juan come manzanas.

THAT'S WHAT I'LL MAKE MY COMIC ABOUT!

FINALLY SOMETHING AMAZING HAPPENS

LAST YEAR, ONE OF MY CURRENT COMICS STUDENTS GOT IN TROUBLE FOR WEARING A MASKED COSTUME HE MADE TO SCHOOL. HE DIDN'T MEAN TO SCARE THE OTHER KIDS BUT HE DID. HE JUST LOVES HALLOWEEN AND IS MORE COMFORTABLE, MORE HIMSELF WHEN HE WEARS THE COSTUME.

TODAY, WHEN HE TURNED ON HIS CAMERA TO SHOW THE CLASS HIS ATTENDANCE CARD, WE SAW THAT HE WAS IN FULL COSTUME. IT WAS AWESOME! NOBODY CAN STOP HIM FROM WEARING HIS COSTUME TO SCHOOL NOW!!

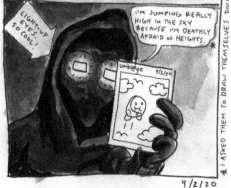

LIGHT-UP EYES? SO COOL!

I'M JUMPING REALLY HIGH IN THE SKY BECAUSE I'M DEATHLY AFRAID OF HEIGHTS.*

* I ASKED THEM TO DRAW THEMSELVES DOING SOMETHING THEY'D NEVER DO

4/2/20

I DON'T WANT TO GET UP. THE ALARM HAS ALREADY GONE OFF BUT I HAVE TURNED IT OFF AND ROLLED OVER. THERE IS A SLIGHT BREEZE, THE TEMPERATURE IN THE SHEETS IS JUST RIGHT, AND I HAVE MY HAND ON HALEY'S BREAST.

I MAKE THE COFFEE AND CHECK THE NEWS ON MY PHONE. TRUMP'S NOT DEAD YET. HE SEEMS TO HAVE LEARNED NOTHING FROM GETTING COVID. HE IS ACTING LIKE A CORN-ERED WILD ANIMAL MORE AND MORE EVERY DAY. "I'M GONNA HOP IN THE SHOWER," I SAY TO JUDAH.

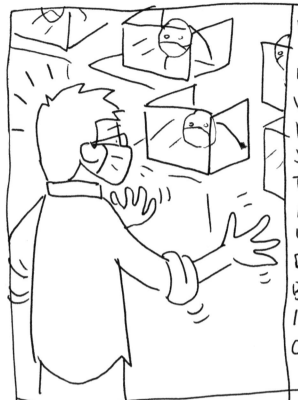

MY STUDENTS ARE INAN-IMATE NON-VERBAL LUMPS TODAY. IT IS VERY DEPRESSING TO ME. MAYBE THEY'RE ALL JUST DEPRESSED. MAYBE THEY JUST CAN'T TAKE ANYMORE PLEXI CUB-ICLES, MASKS, AND SOCIAL DISTANCING. I GET THAT BUT THIS STILL SUCKS. I CAN'T GET ANYTHING OUT OF THEM AT ALL.

AFTER SHOOL I PICK UP JUDAH. HE HAS A HEAD-ACHE. WE PICK UP 3 BAGS OF SAWDUST FOR OUR PIT-FIRING NEXT WEEKEND. ON THE WAY HOME HE PUTS ON SOME MINUS STORY BUT SOON TURNS IT OFF. WILL MY STUDENTS BE OKAY? THEY SEEM SO FRAYED.

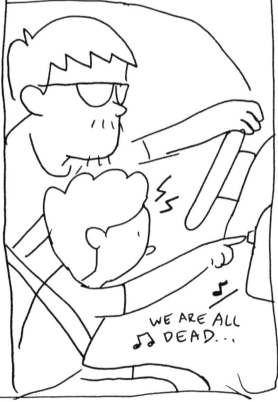

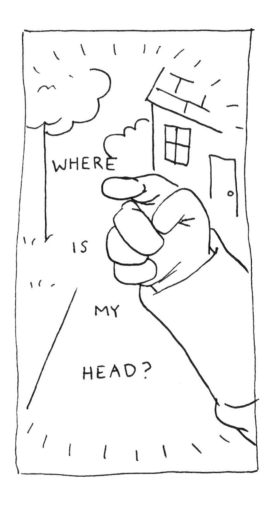

I AM SO STRESSED OUT ABOUT OUR FURNACE.. WHAT IF IT IS TOO BROKEN AND WE HAVE TO GET A NEW ONE? HOW LONG WILL THAT TAKE?

WILL MY STUDENTS BE MORE ENGAGED ON ZOOM TODAY? I DON'T UNDERSTAND WHY THEY DON'T DO WHAT I ASK, EVEN WHEN IT SEEMS SO SIMPLE TO ME..

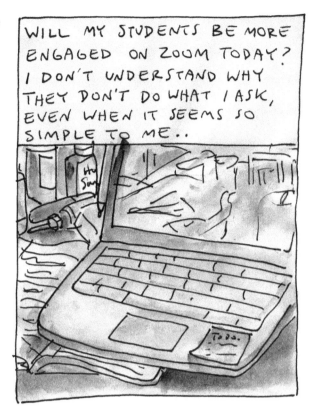

IT'S AS IF WE ARE SPEAKING TOTALLY DIFFERENT LANGUAGES.. MAYBE I'M GETTING WORSE AT COMMUNICATING.. MAYBE IT'S DUE TO A BRAIN TUMOR?

HOW CAN I TEACH THIS CLASS BETTER NEXT SEMESTER? MAYBE I SHOULD JUST TURN IT INTO SOME KIND OF VISUAL JOURNALING CLASS...

CIRCLE, I GUESS

JASON LIPS

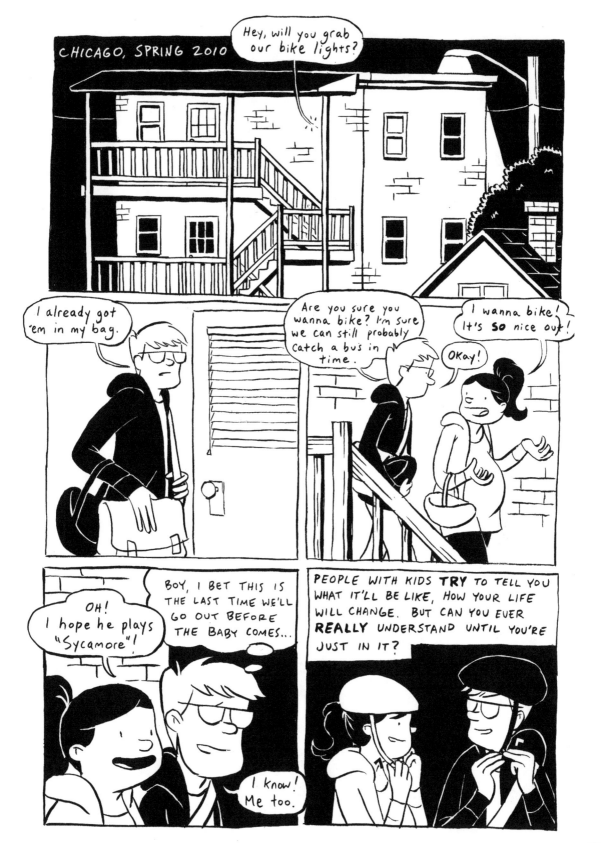

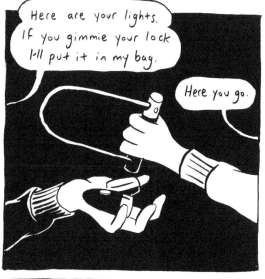

Here are your lights. If you gimmie your lock I'll put it in my bag.

Here you go.

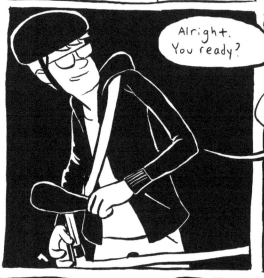

Alright. You ready?

Yep! Let's do it.

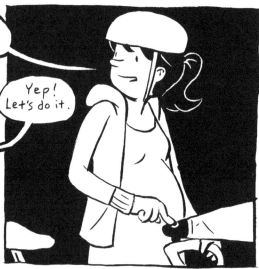

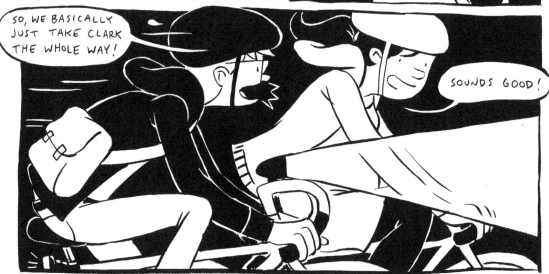

SO, WE BASICALLY JUST TAKE CLARK THE WHOLE WAY!

SOUNDS GOOD!

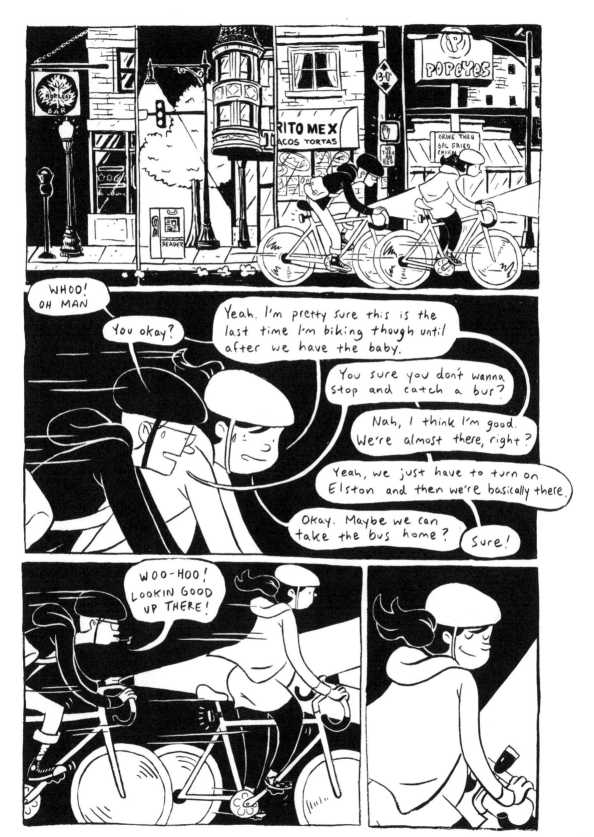

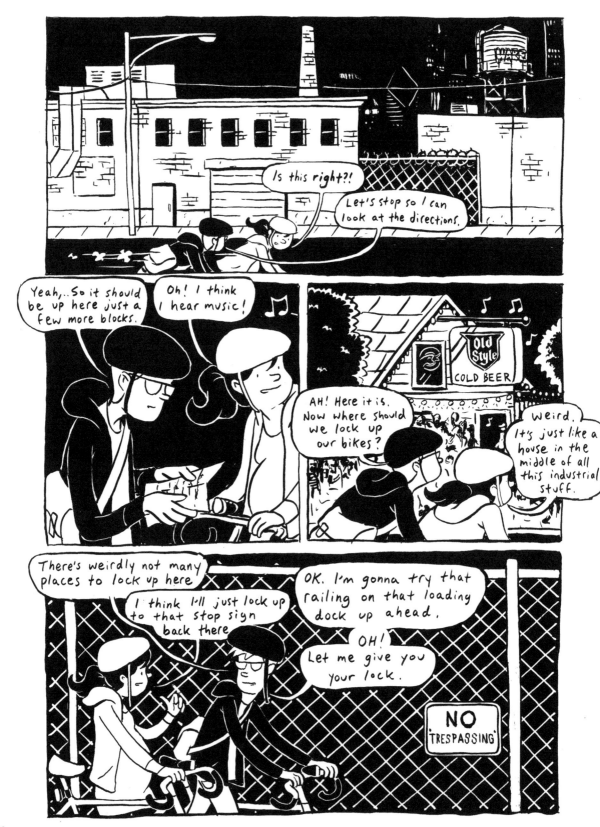

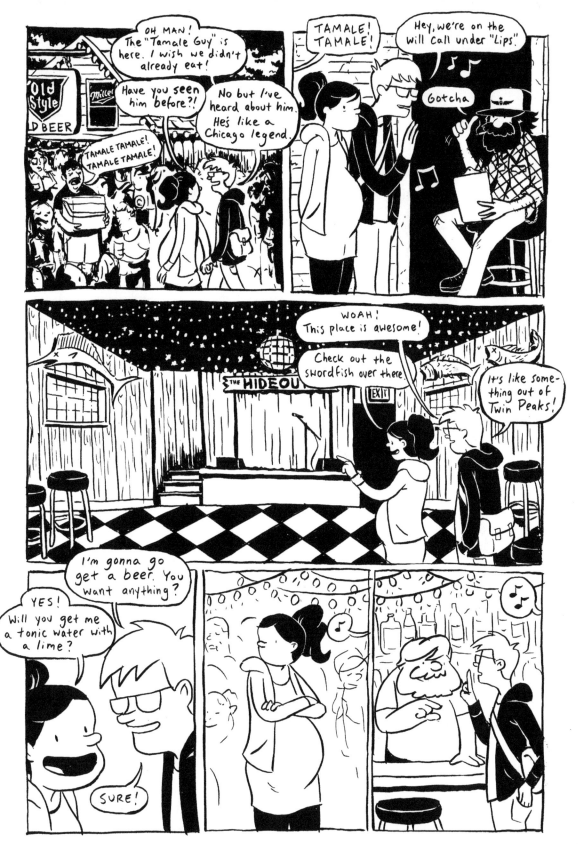

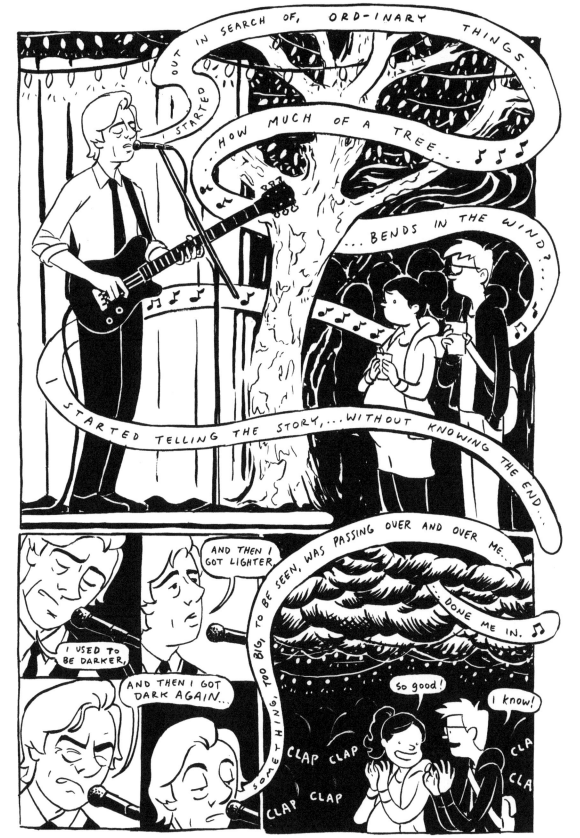

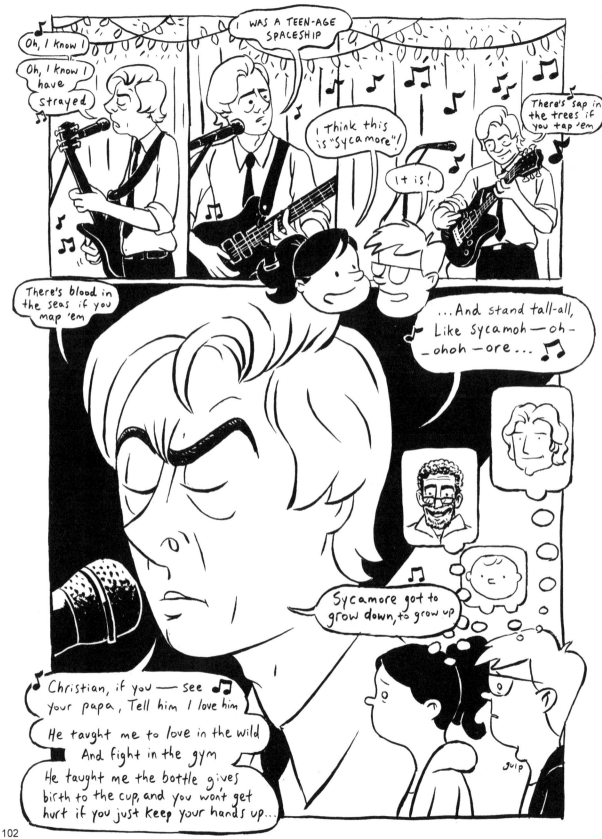

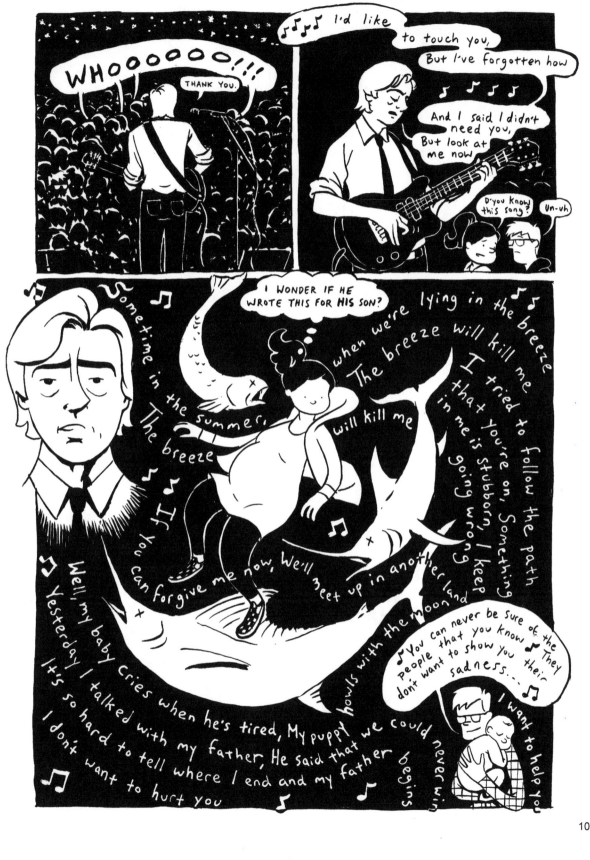

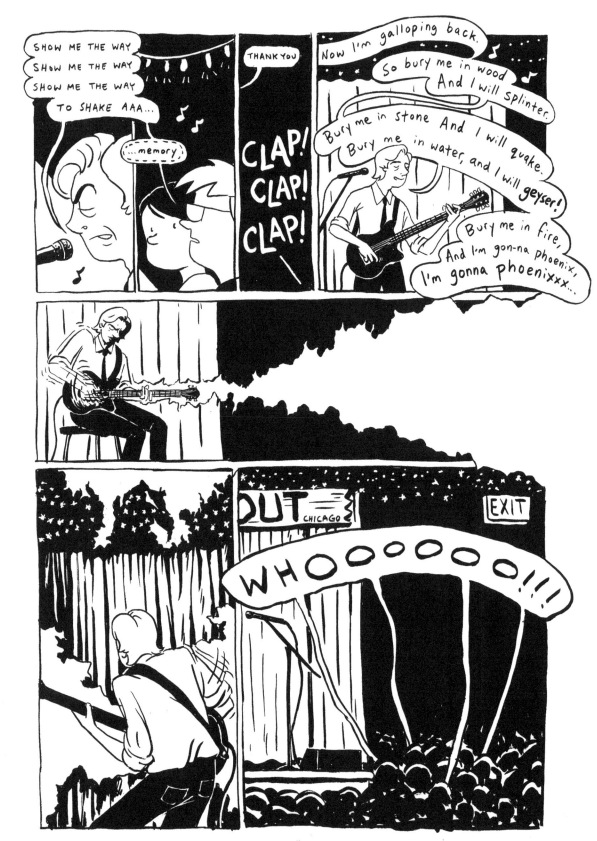

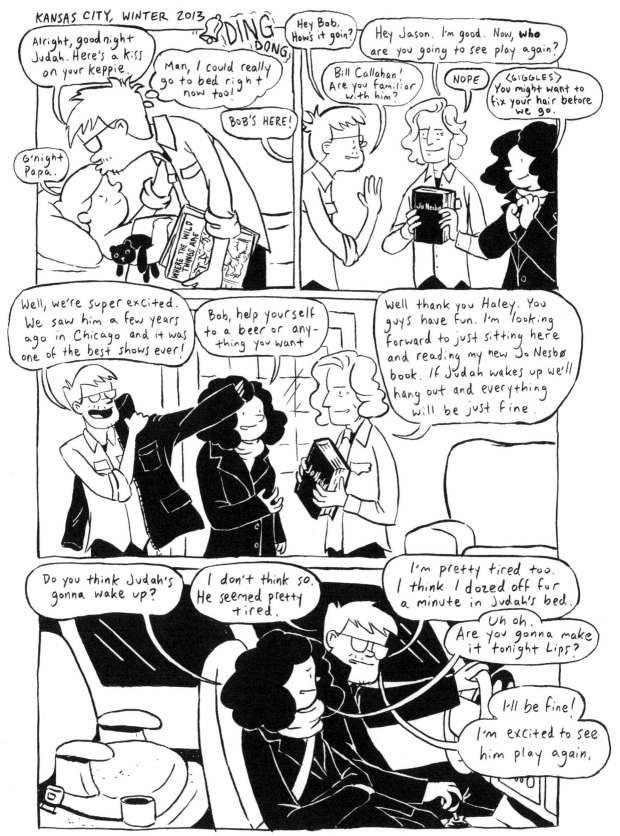

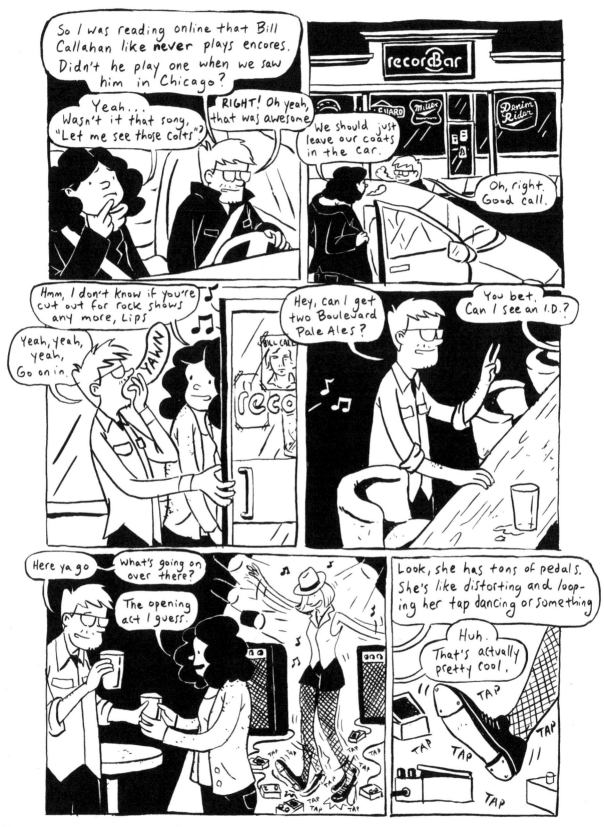

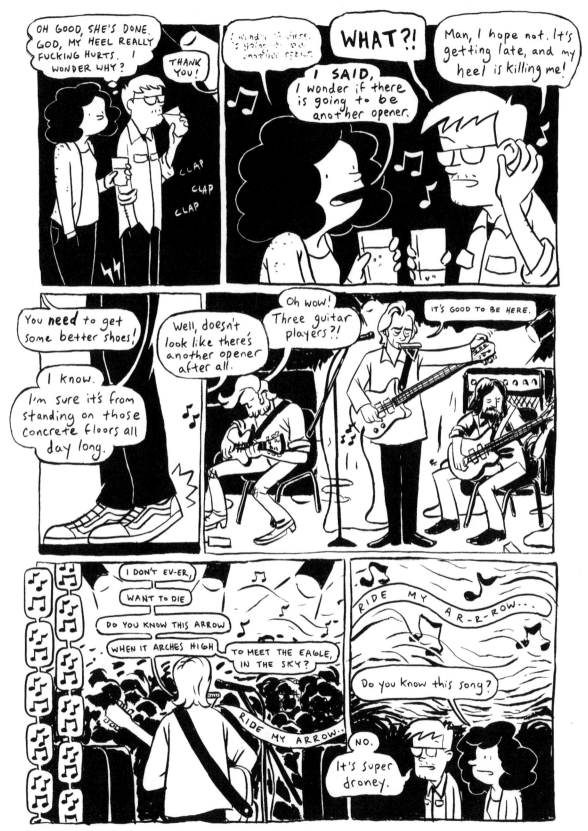

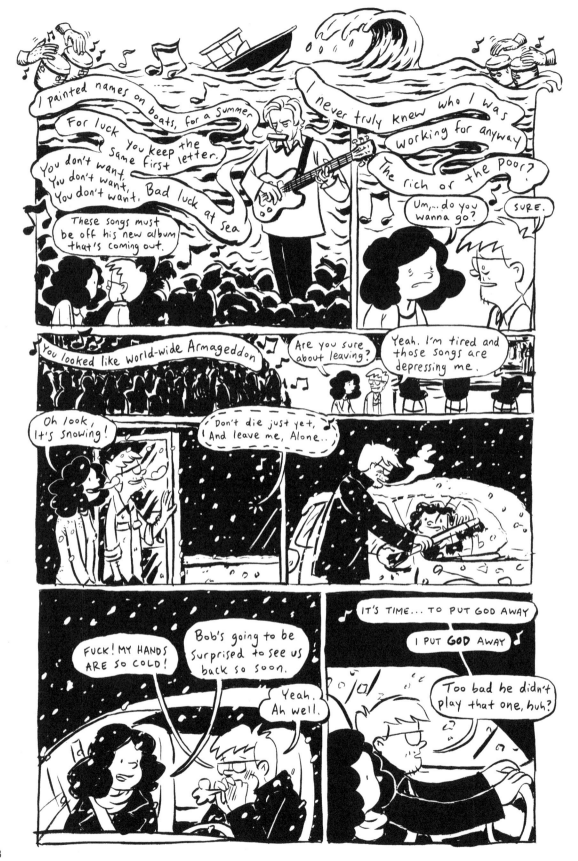

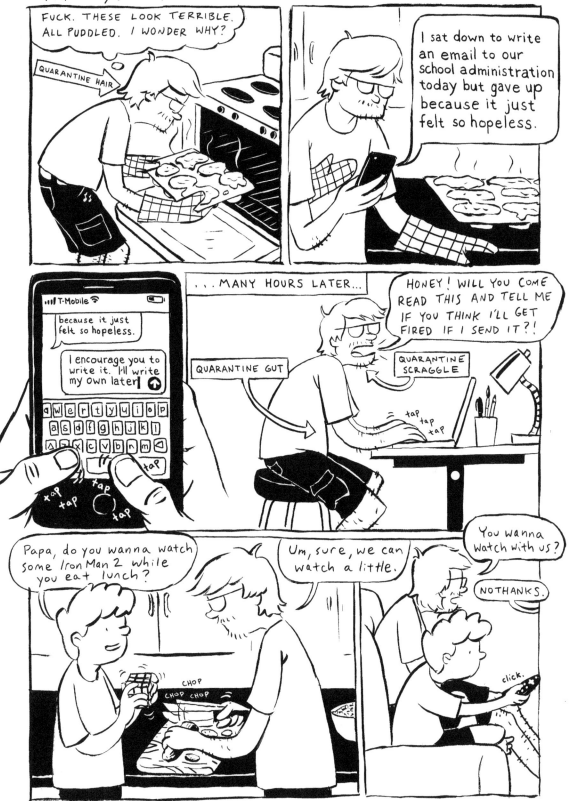

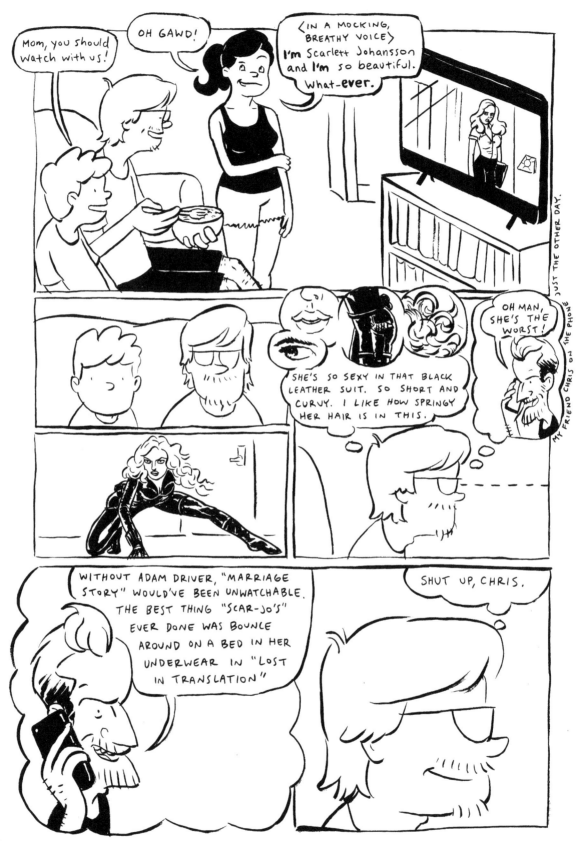

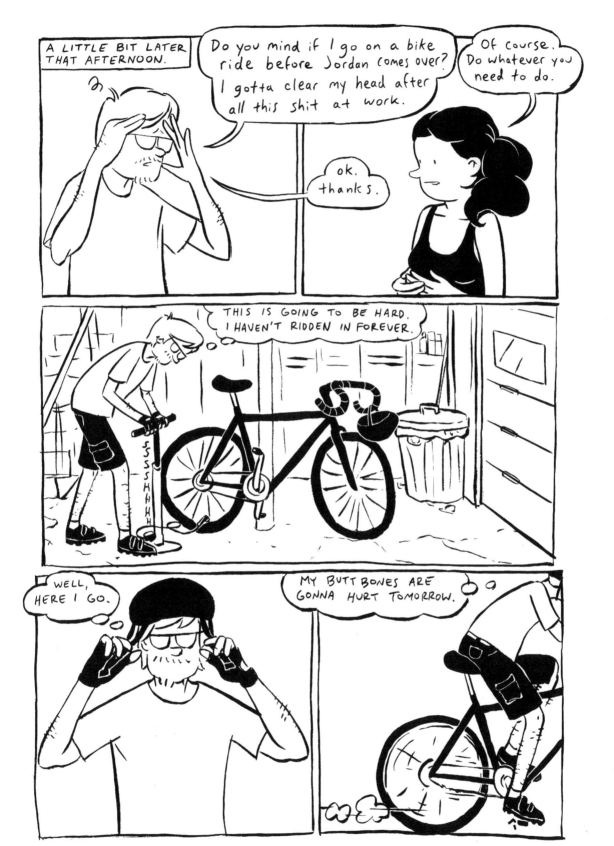

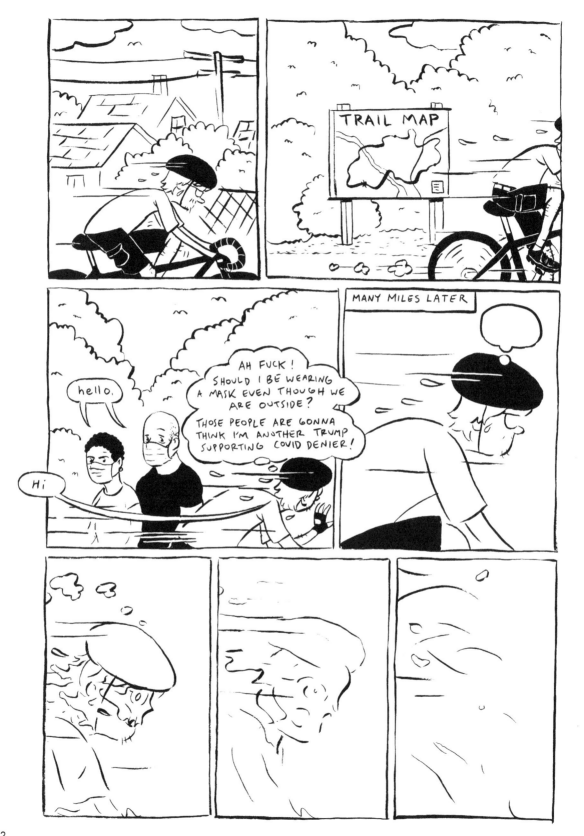

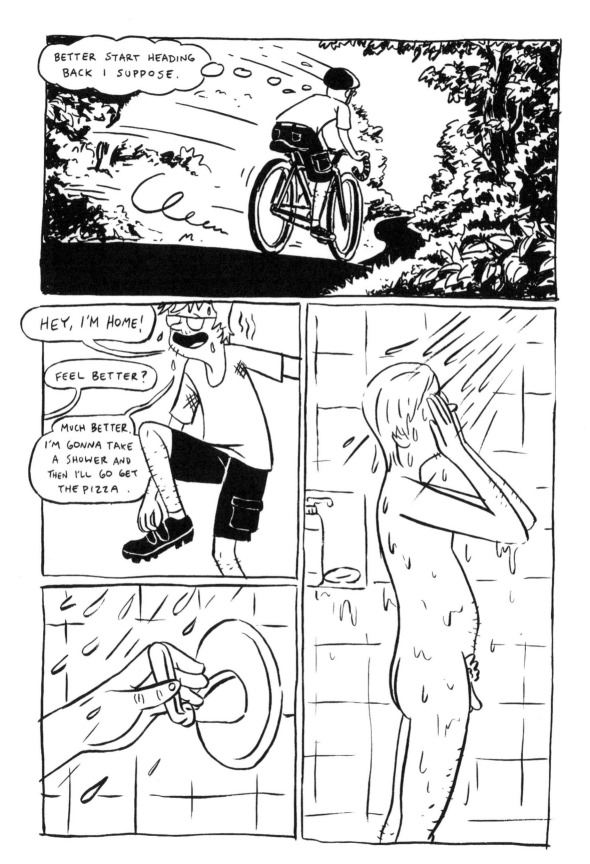

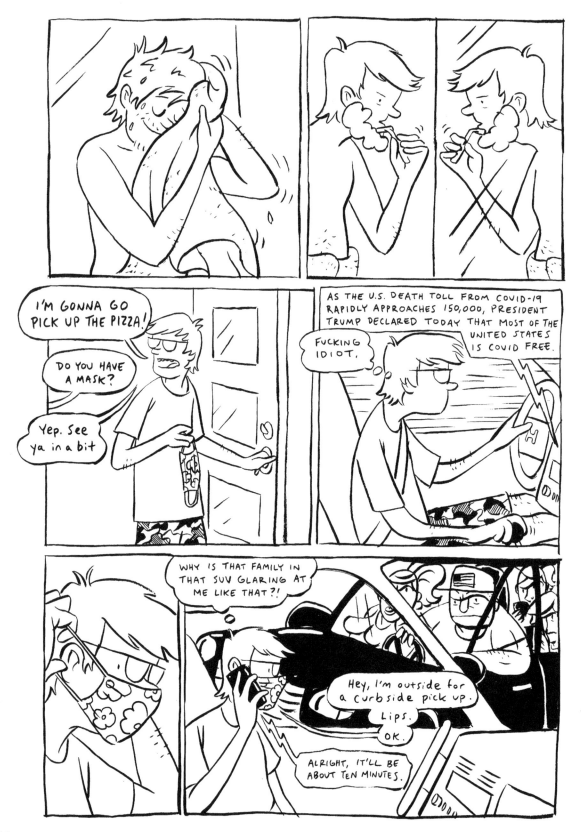

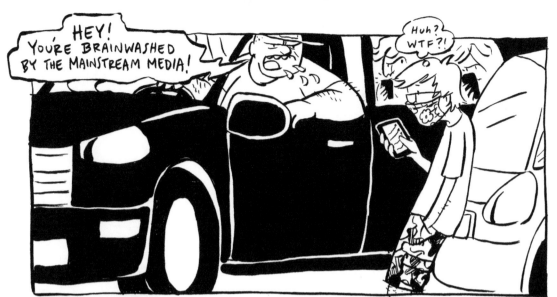

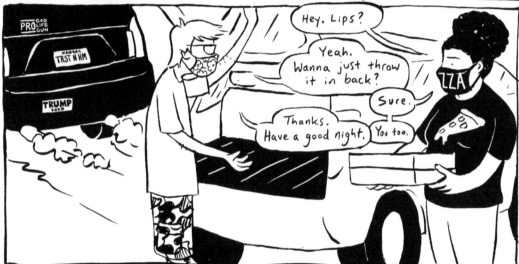

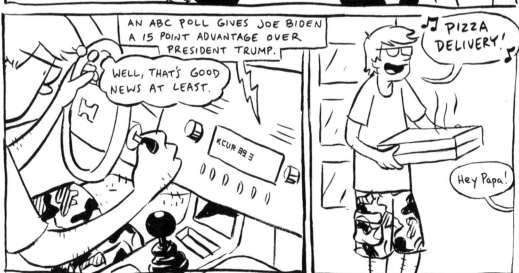

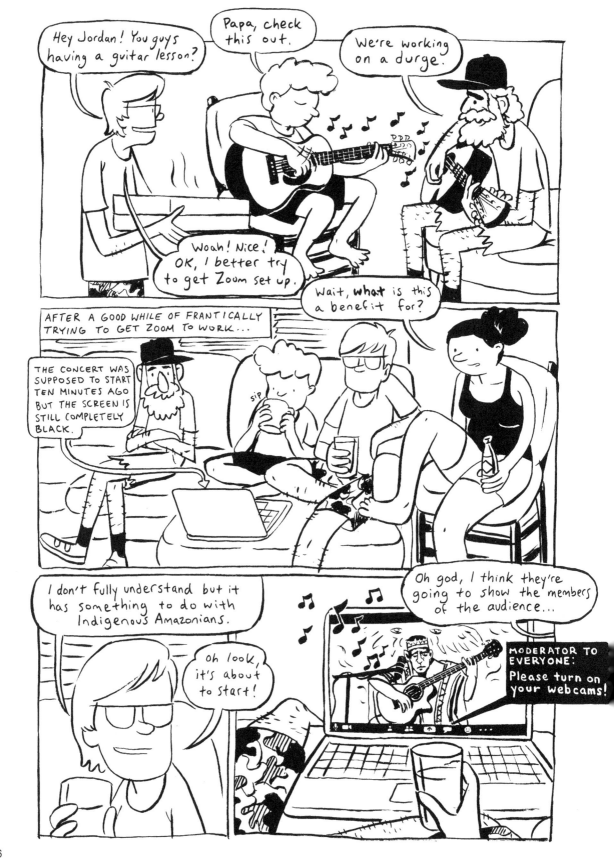

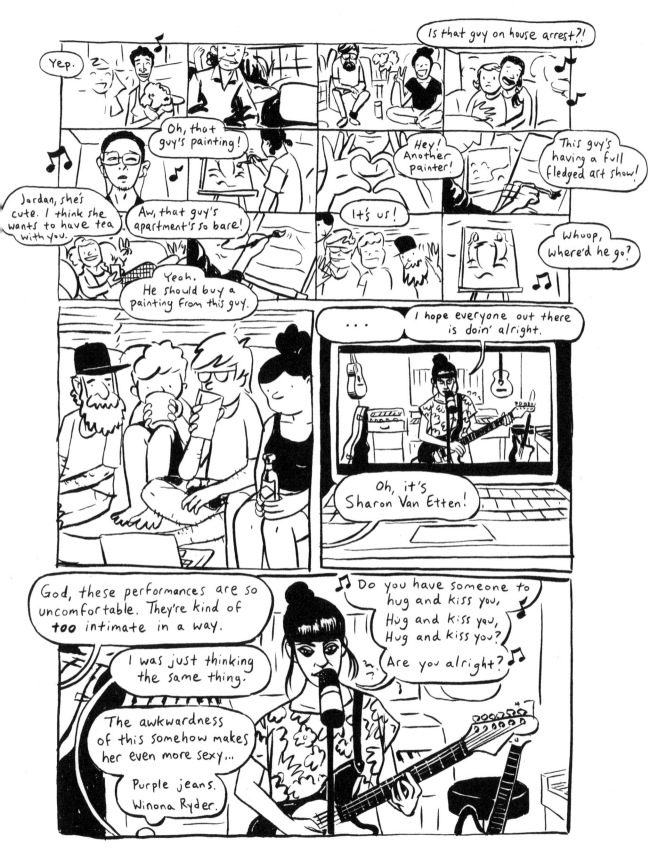

117

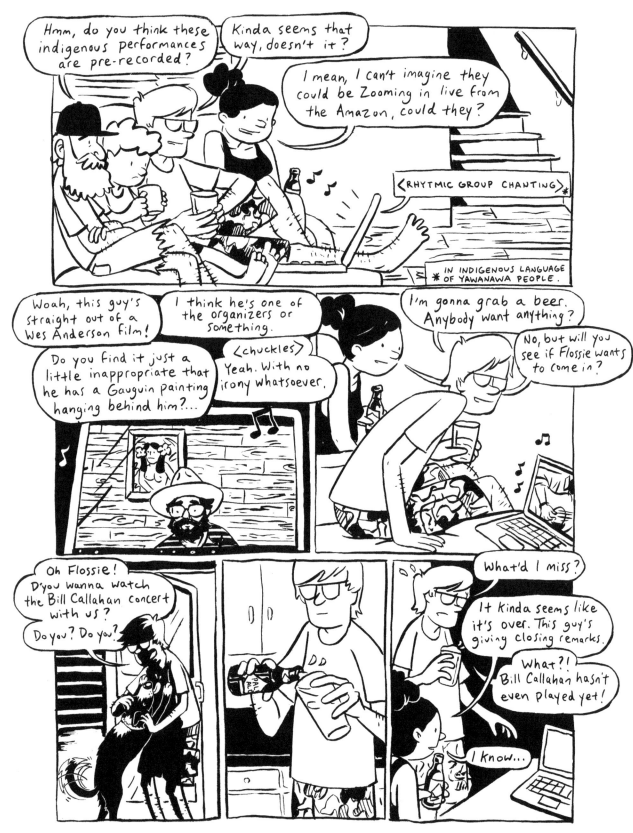

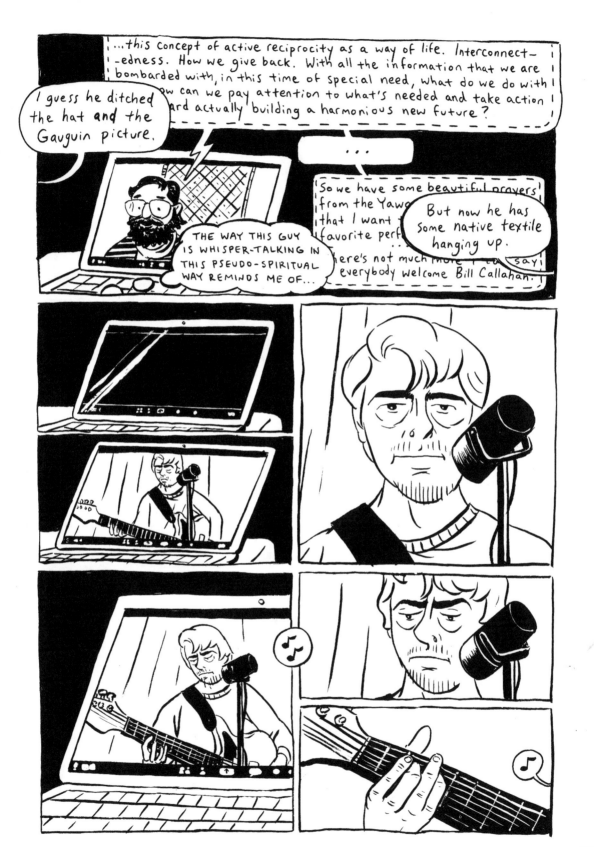

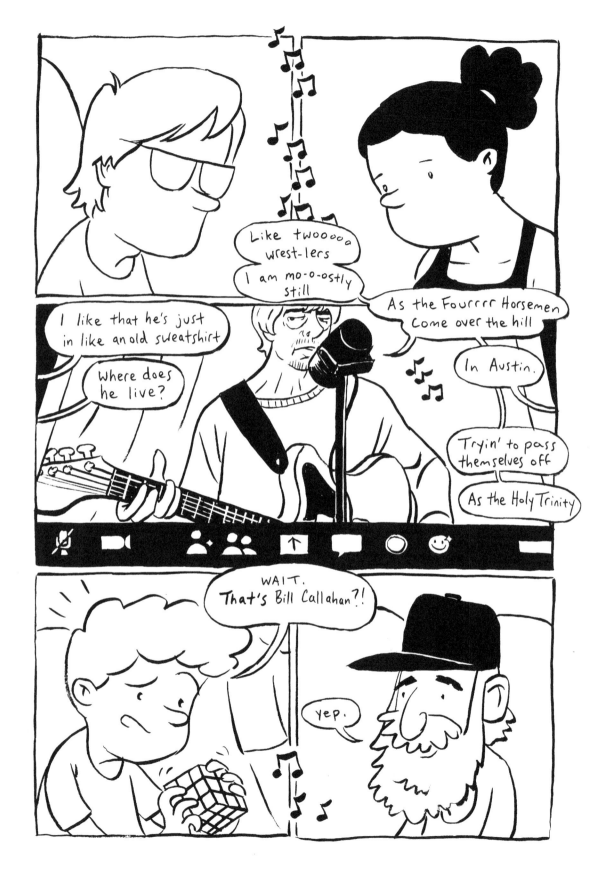

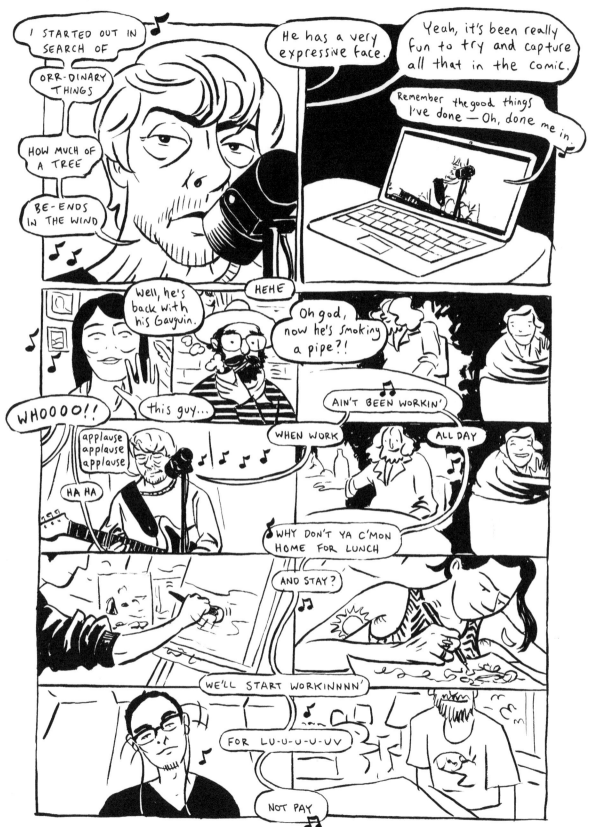

121

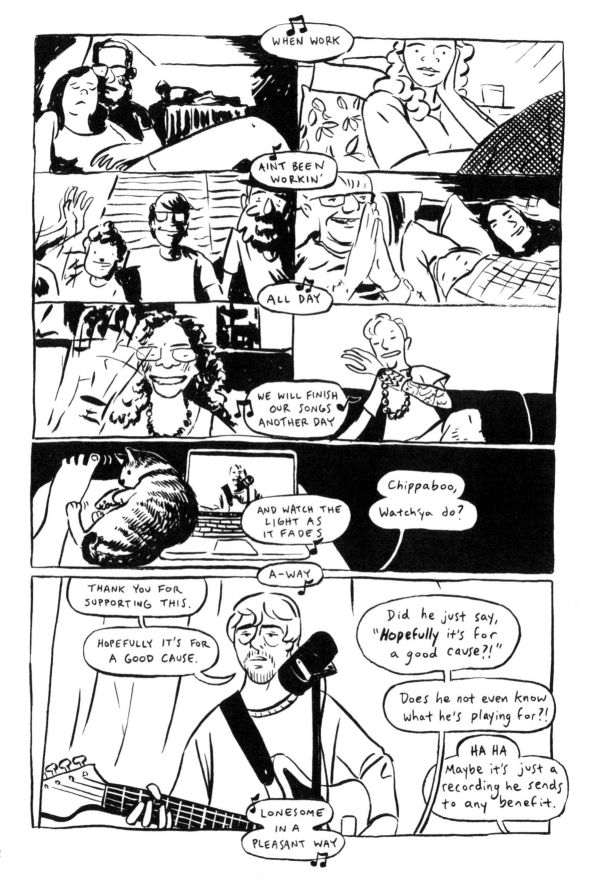

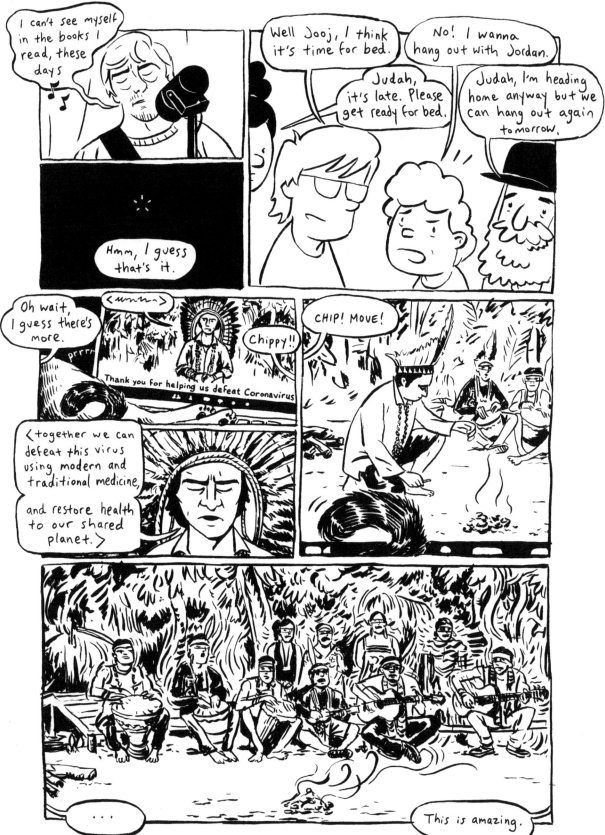

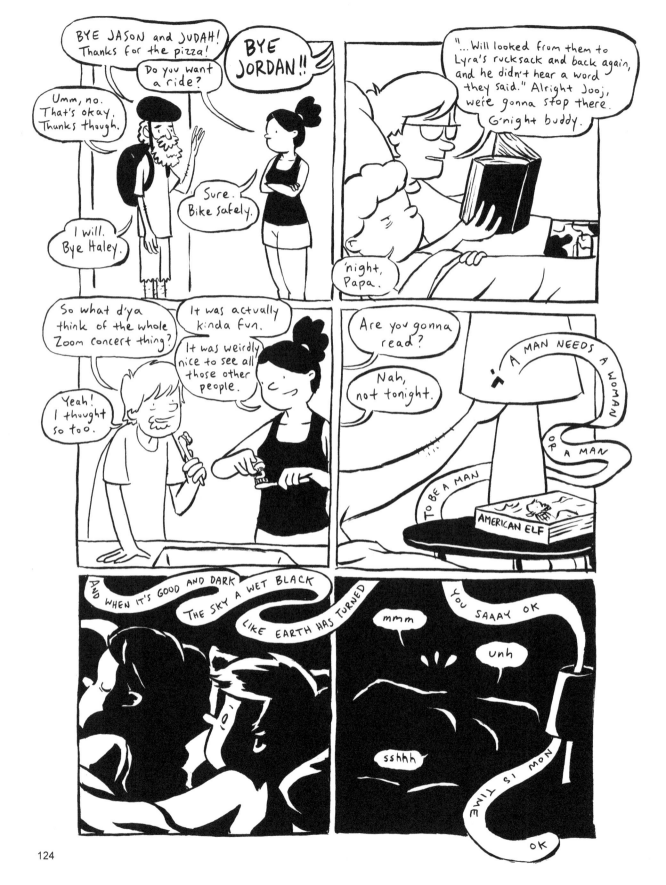

124

BY HALEY

BY JUDAH

SELF PORTRAIT

Jason Lips lives and works in KC.
For money, he teaches teens the joys
of making art. His true passion is the
creation of comics, ceramics, food, and
coffee.

He lives with his wife, son and
3 dysfunctional animals.

He is loved by all of them.

CPSIA information can be obtained
at www.ICGtesting.com
Printed in the USA
LVHW070001300421
686058LV00021B/1515